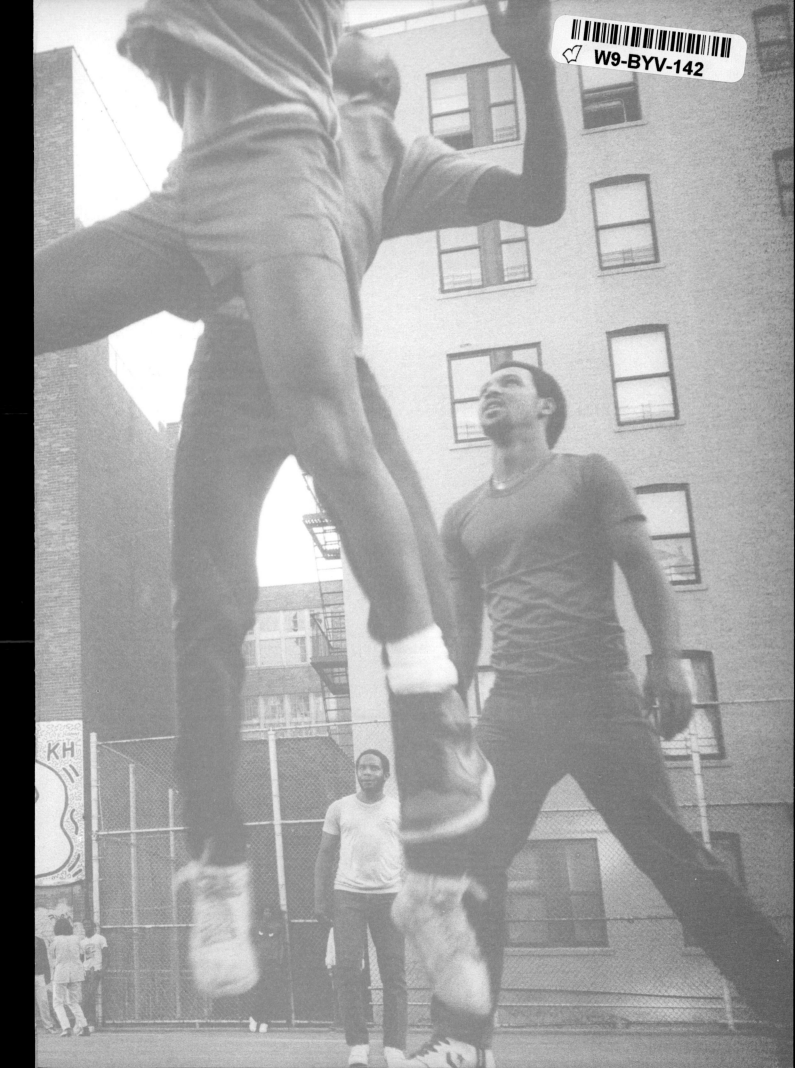

KEN HEYMAN

HIPSHOT

ONE-HANDED,
AUTO-FOCUS
PHOTOGRAPHS
BY A MASTER
PHOTOGRAPHER

FOREWORD BY
PETE HAMILL

INTRODUCTION BY
DEBORAH
EISENBERG

APERTURE

FOREWORD

CATARACTS OF INDIFFERENCE BY PETE HAMILL

In a vast, dangerous city like New York, the inhabitants see everything and nothing. For too large a group, the sense of the marvelous is dulled by an abundance of courses offering some fresh affront or elegant attraction. The table is spread with such a grand selection of pleasures and temptations that the choice is often to eat nothing. For others, the enemy is time; after the passage of years, habit fogs the urban eye. Too many New Yorkers, hurrying to their gnawing appointments, become indifferent to the density of the lives that surround them. Only the novelties of death and disaster seem capable of demanding focus. No wonder the casual visitor leaves convinced that there is simply too much of New York for it to be knowable. No wonder so many New Yorkers can no longer walk the streets and be moved by their drama, intimacy and humanity. Urgency remains the most implacable enemy of the heart.

All of this is quite sad, because at all hours of the day, the city offers its lessons and novelties to those who still possess an innocent eye. I am not speaking here of architecture, monuments, roads, or bridges, although these have their own special beauty (especially after acquiring the patina of age). I am speaking of people. A bridge or a skyscraper is static; you can admire its formal design, its function in the city's grid. But man's creations never match the appalling variety of man himself.

On the streets of the city, we can observe novels unfolding before our eyes if only we stop to look, and after looking, try to see. Here, on a scalded beach at Coney under an August sun: the young man looks, the woman nods, and two lives forever change. On this tenement stoop, a man revives some ancient capacity for passion in the embrace of a black woman with forlorn eyes; how did he reach that place and who is the woman and what on earth will become of them both? In that schoolyard, with bodies still hard and lean and supple, ball players imagine the applause of absent thousands; what accident of genes or luck kept such men

off the courts of giant arenas? Flesh carries the sheen of youth, then coarsens into middle age before growing gnarled and withered by the unceasing pressure of the city. Look at these hands, their intimate movements, grasping, holding back, caressing—or flopped into stillness from exhaustion. Look into the eyes of those strangers: wariness is there, or bafflement, pity, hostility, hope. But laughter too. And love. Look, and you might see the thousand small collisions that make up a New York day, the moments of repose, the concussions of energy. You will most certainly see its casualties.

In a way, the very pelting complexity of the city and its people is what leads to the general blindness; to refuse to see is a strategy like any other. One simply cannot have enough pity for all the lost and defeated human beings who populate the streets and the welfare hotels. After a while, they cease being individuals and become Social Problems, defined by statistics, graphs and lines in municipal budgets. Once confined to their abstract nooks, they lose their ability to make us uncomfortable. And alas, while avoiding the sight of them, we also lose sight of the true city.

Since its beginnings, that city has been revealed by its artists, writers and (for the past century and a half) its photographers—those who see most clearly what the exhausted eye will not accept. The city they have shown us is at once mean and sentimental, puritanical and erotic, greedy and generous. They have chronicled its horrors and corruptions. They have shown us its secret beauties. Above all, they have taught us to see.

In this book, Ken Heyman joins the company of all those artists who have made all of us more human. Walking the streets of the city, free of the cataracts of indifference, you can somtimes see what you least expected: yourself. In that lucid clarity, with a shock of recognition, you stand naked, with all of your defeats and triumphs in view, your virtues and follies. It is often the most extraordinary sight of all.

INTRODUCTION

BY DEBORAH EISENBERG

It is generally understood that New York, in our period, has been the city to which people come, and that what a New Yorker is, is the thing that anybody can be (or can think up to be). We owe it to this that New York's nature is active and incompletely determined, that its condition is one of continuous renewal, and that it is representative, in its extremes, of impulses which elsewhere can be hardly distinguished. What we expect from New York is its germinating power, the harsh, lush culture in which flourish the stunning invention and pragmatism of its citizenry. What we cannot expect is the forms this will take.

As I remember, New York was always the place I wanted to be, and when I arrived it was with an album of those expectations by which we represent to ourselves the allure of one place or another. Naturally, that album has been supplemented and revised over the years I have lived in New York, yet how shocked I was upon first looking through these photographs. Here was a city which I had encountered daily, but had thrust to the periphery of my consciousness.

How could anyone be doing that? (we might think over and over as we turn the pages.) Or that? And furthermore, just what exactly is it? How could anyone be wearing that? Or being that? All this strangeness, and all this exercise of ingenuity is somewhat overwhelming as we walk by it on the street, and perhaps because it is so difficult to comprehend or interpret, it does not easily slip into our minds. But in these photographs, we are confronted by it.

Here, right in front of us are all these *people*, lolling about, refreshing themselves, staging spectacles, or just going about their own unprecedented lives. While I've been dozing in my received New York, very pleased with its brownstones and bridges and stone lions and broad avenues, so many others, with other things on their minds, have taken this wealthy fortress into their own hands to redefine the terms which have been imposed upon them. And although it might be difficult to believe that a world has come into existence from which these photographs could issue, we know that it has because here is the record—which calls to mind the proposition that if an ecological niche is filled, it must exist.

Ken Heyman's New York is a city that exists in open air and plain sight—every one of these photographs is of a public exterior—and anyone who lives in New York, or who has visited recently, will recognize it immediately; we have seen this city, and although it is a tendency to replace what one actually does see with generalized or cliched fabrications, we cannot do that here, where close attention is all that is available to us. In fact, the photographs put us into a much closer relationship with their subjects than, under ordinary circumstances, we would have, or might want to have, with them. And although in their elan and commotion the pictures suggest snapshots, the figures in them are monumental—gravid and immense—and the presentation of them (they are shot very low as well as very close) is often claustrophobically or excitingly restricted, and oddly angled. The animation, the grandeur, and the idiosyncrasies of scale in these pictures are themselves characteristic of New York, pressing upon us a view of the world available, for example, on the subway at rush hour, when the thigh or armpit of an utter stranger might constitute, however briefly, our milieu.

Things look quite different at this range. Where is "New York"? The landmarks? The skyline? The stage set for so many characters and events we think of with affection? They have receded here to inscrutable backdrop—a distant and incon-

sequential given. That shadowy structure, for instance, beyond the peculiar marsh where those people are sloshing about with their gigantic (possibly prehistoric) dogs—is that the Beresford? Probably, in which case the peculiar marsh would have to be the lake in Central Park! And what is this field of living paper, where a group of city nomads confirm, in their sleep, the circuit of their ties to one another? Locations, areas, and types of places that were well known to me a moment before, become unfamiliar here, as though they were being converted, by some process of decomposition, into the raw materials out of which other things are forming.

In addition to this protean quality, many of the pictures contain a disorienting complexity of image, which requires scrutiny to disentangle. Sometimes it's difficult to tell at first glance who is right side up and where the sky is, or from where we are seeing someone. There is a frequent interpenetration of the organic and the inorganic—masks, mannequins, dolls, and statues that look like people, as well as people who look like masks, mannequins, dolls, and statues—and sometimes it's not immediately clear which figure is human, what belongs to whom, or whether we might not be looking at some newly coined body part. The sphinx that hunkers on the sand, for instance, looking out to sea, reforms itself into a woman bending over a child; that war memorial turns out to be not a war memorial at all but to be part of a parade; the sculpture of Neptune becomes a fellow relaxing on a stoop, but the lively nude diving at the feet of the two stationary figures turns into a sculpture; those extraterrestrials who have evidently arrived to infiltrate us—and perhaps they have already colonized the city—or to take us away on the space ship that hovers behind them simmer down into a couple of plain old human beings in Garfield-the-Cat suits, standing in front of a Garfield-the-Cat float.

In many of the pictures it remains virtually impossible to tell exactly what we are looking at. The odalisque who seems to be suspended in a private, curtained ether, looking out onto the street—where is she, and where are we seeing her from? And what about the person who appears to be sunbathing in a tiger-skin pit at the foot of the city? Even when we do know what we're looking at, we often don't know what it means. Is that a man selling ocarinas, for instance, or is it a man selling revolution? Or could it be a man be selling ocarinas for revolution? And the blonde in the motorcycle hat who is bending over the infant—is she (or he) attending to the infant, or doing something unspeakable to its foot?

Some variety of ambiguity permeates all, or almost all, of the photographs. Is this street exhibition a celebration, or is it the eruption of some catastrophe? Is that child resting or unconscious? (Or dead?) Are we on the verge of a fight, or is this the resolution of a problem? Are we looking at the inception or the dissolution of a friendship? In any case, relationships are certainly being realigned. Is this an instant of tenderness? Torture? Incest? Are the bathers cavorting or fleeing, playing or struggling? Is that a collection of casual bystanders or an aggregation of appalled witnesses? That man, lying there on the rocks—is he sleeping, or has he been crucified, or was he thrust up to the surface by some volcanic activity that created the ruin in which he is lying? And those men walking about in the distance behind him—what are they doing there? Are they mourners? Fellow workers? Archeologists? Killers? Searchers?

But it is only after we have penetrated one of the photographs and have gotten a pretty good idea of what is going on inside it, that we become aware how profoundly intractable that photograph is. And at the very moment we select a name

for the thing that is happening there, it becomes apparent that the name is at best a convenience. Of what possible significance could it be to realize that the thing we are looking at is "only" a performance—is it any less powerful and strange for that? Does it allay our distress to comprehend that it is wisps of hair, not blood, on the face lying next to the giant shoes? Are we deeply reassured to see that the abandoned, caged child is really a child waiting in a shopping cart? If we could know what has just happened between the black woman and the three white men on the stoop, would we be better equipped to understand the true nature of their interaction? I think not.

Individually the photographs could be considered pictures of the interstices between namable moments, pictures of stuff coalescing, unstable compounds, but it seems to me that when they are considered as a group, the consistency of all this inchoate movement reflects, and powerfully urges, the radical view that what we consider an occurrence is just what we receive in a glimpse of a process. That this is a such-and-such, that it is something we enjoy/don't enjoy, approve of/dis-approve of—all this seems artificial and very much beside the point. Each picture is alive with alternative or conflicting messages, each represents the contradictory tendencies of a moment—one interaction taking place at the expense of others, a certain motion forming out of the breakdown of a different motion, essentiality draining from one detail and charging another. An inflammable, and possibly in-cendiary, volatility animates these photographs—the volatility of the world they represent. And there is a potential violence throughout that seems unpredictably quiescent or kindled, a feeling of life forms evolving from the sidewalks, combustion, release, dangerous improvisation, potent fury, armies of strangers spontaneously massing.

But it is the coolness of observation, the fact that each photograph speaks for itself, that nothing is pointed out or superimposed, which ensures that even those photographs whose content is truly extreme or bizarre are never vulgar or senti-mental; there is a clinical thrill to looking at them, as though they were offshore sightings, through a telescope, of a society previously unknown to us, or a glimpse through a microscope of something forming in a petrie dish. And it is the very lack of manipulation or suggestion that seems to me to expose the baffling core of mean-ing in the individual photographs and in the striking and ramified juxtapositions of them.

In fact, there is a progressive and cumulative effect to the collection—a tension of the inexpressible straining toward manifestation—and looking through it, one might come to have the feeling that one is looking at things deeply buried in the images; allegories, implicit in the events of the photographs, that have been for-gotten or were always incompletely known. The difficult and active relationship that we as viewers must have to the photographs holds us in the difficult and un-settling proximity to the subjects in which the camera has placed us. We cannot back up to see their context, and we are not going to be provided with "information" that would help us to "understand" them. On the contrary, the impact and integrity of the photographs depend on the scrupulous elimination of such information. What we are provided with is the expression of an instant which is utterly itself and which compels our unmediated response, and time and time again, what we experience in the photographs is not a mystery that results because something is missing or unseen, but the mystery that resides in what it is that we see completely.

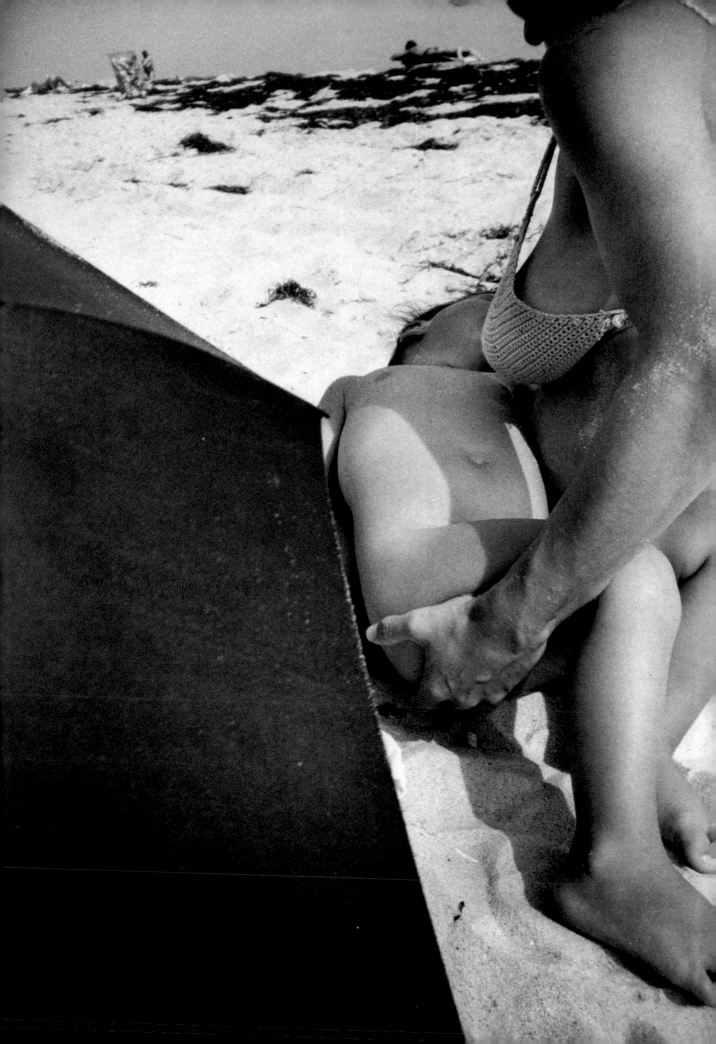

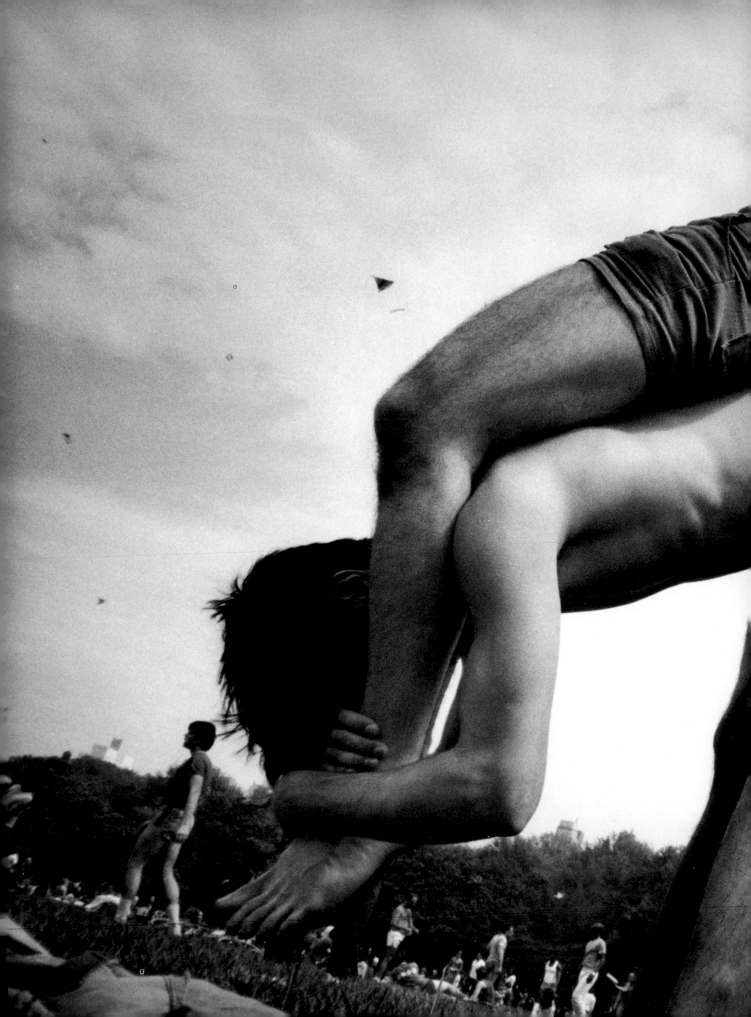

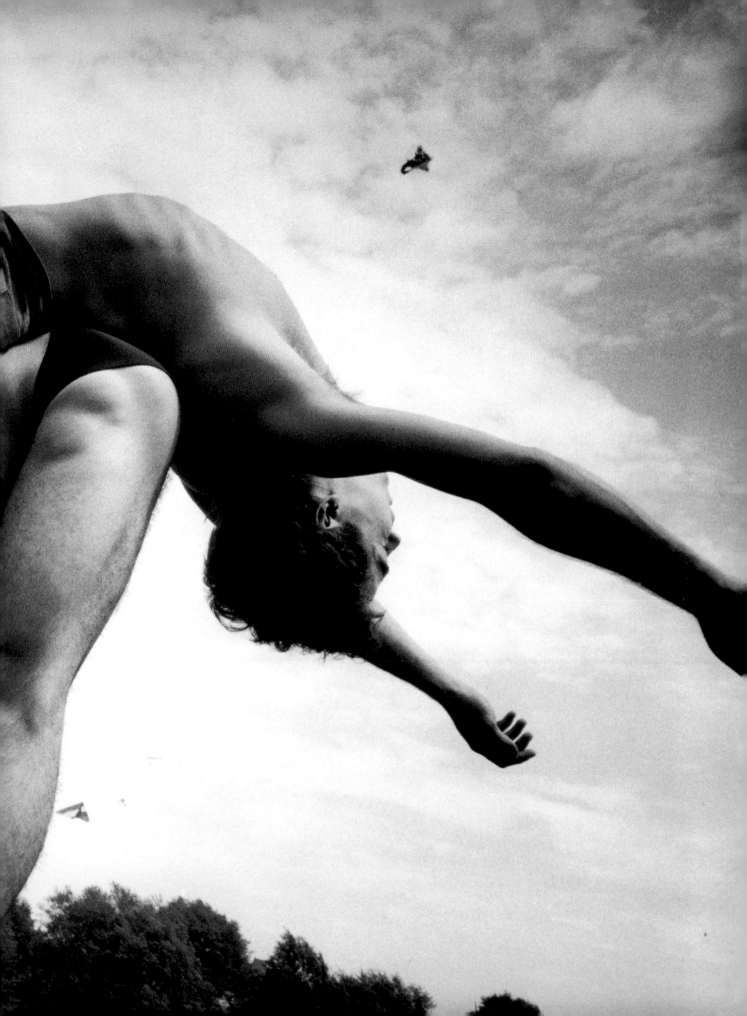

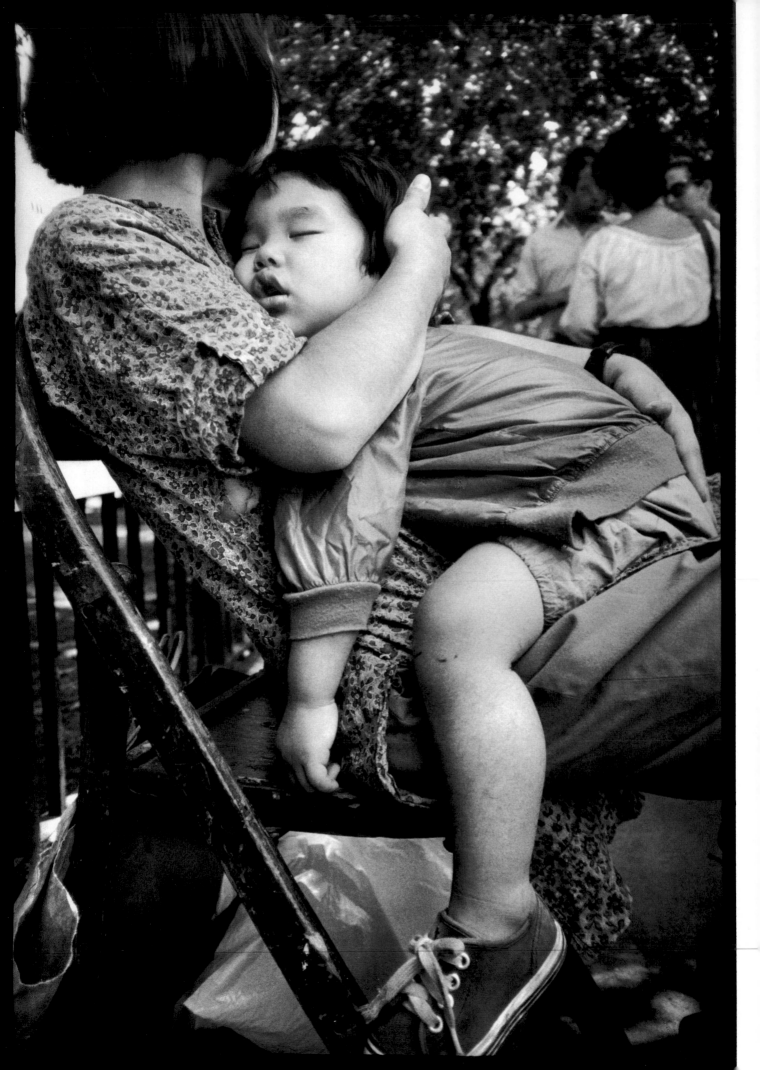

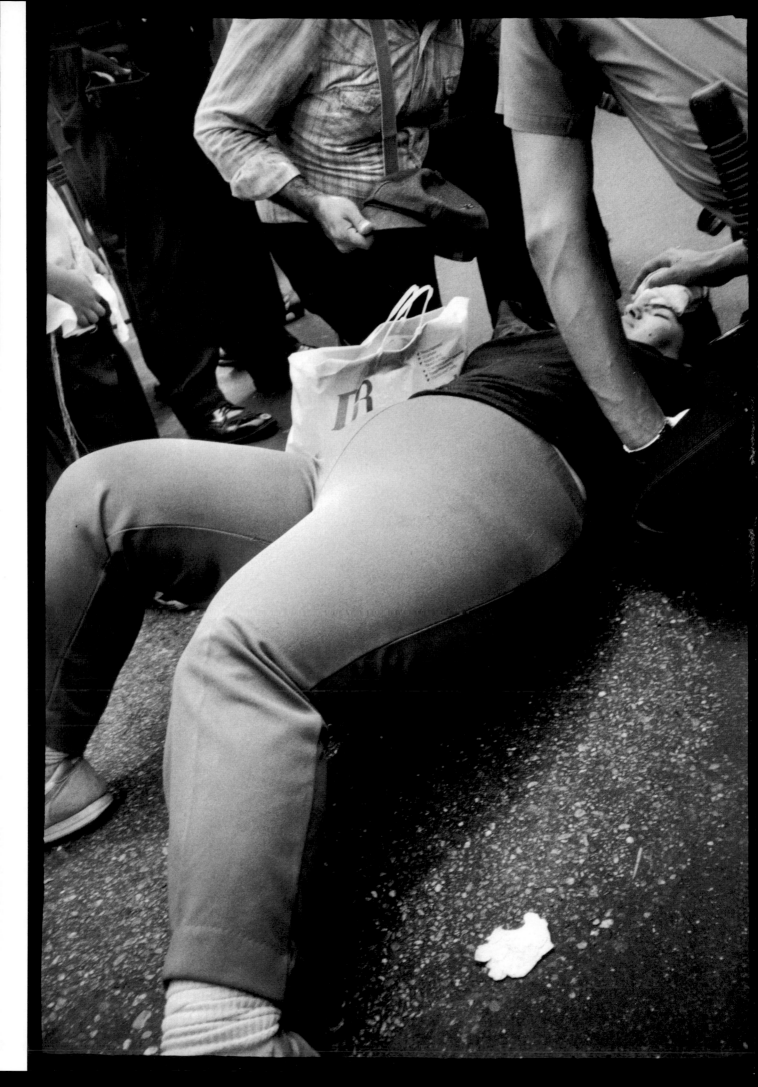

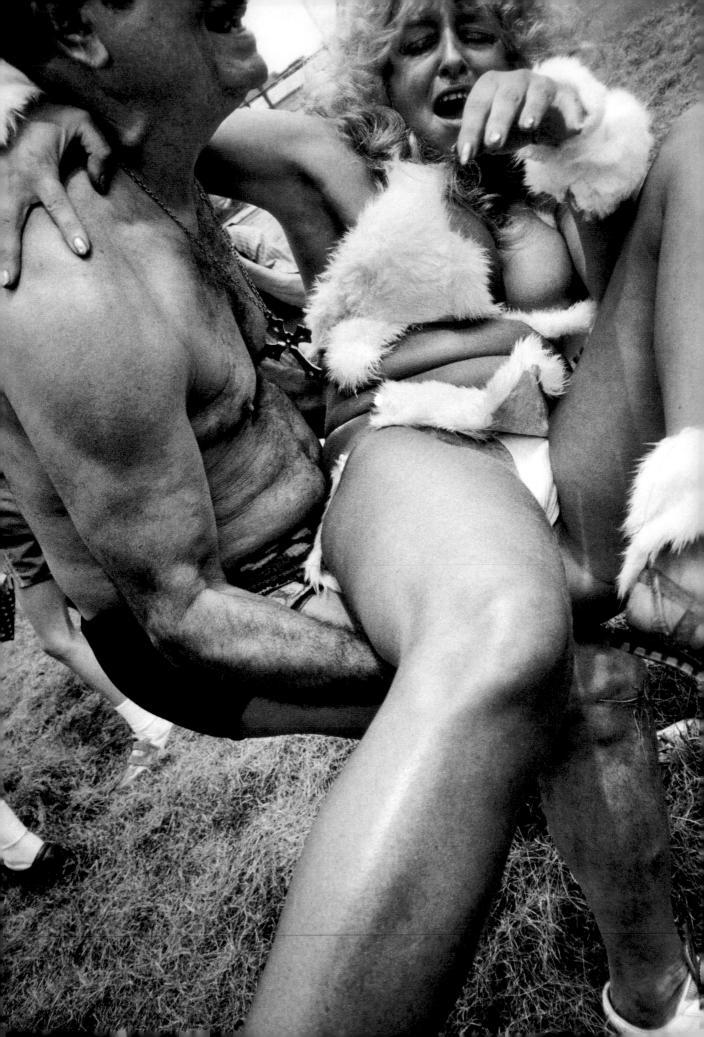

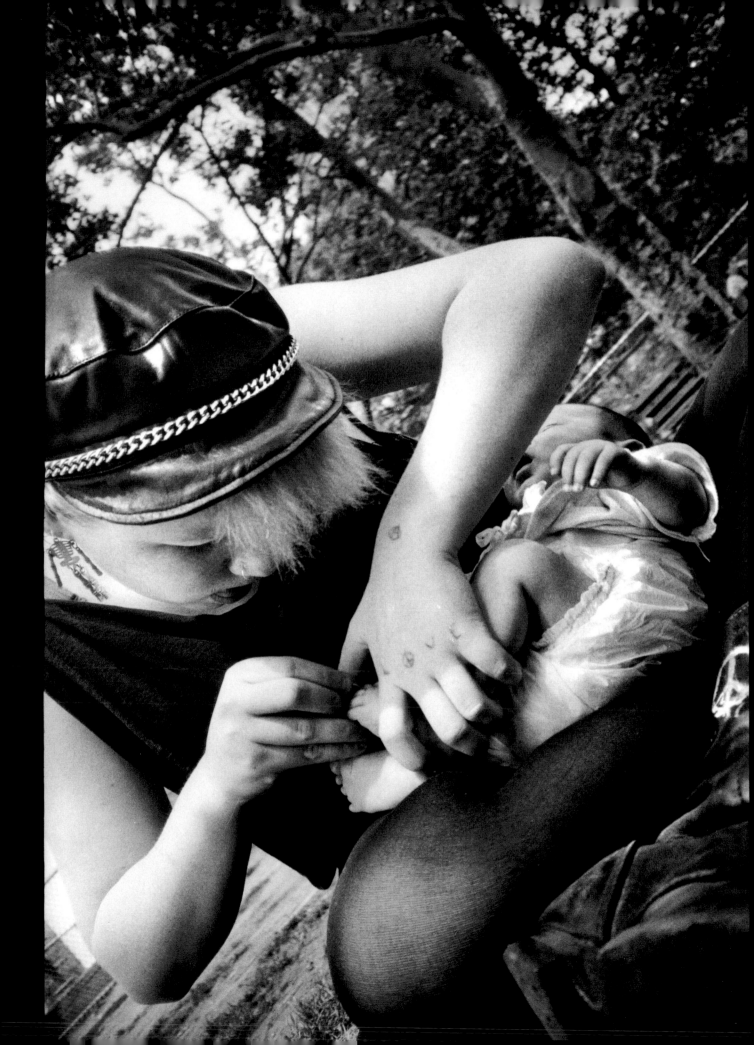

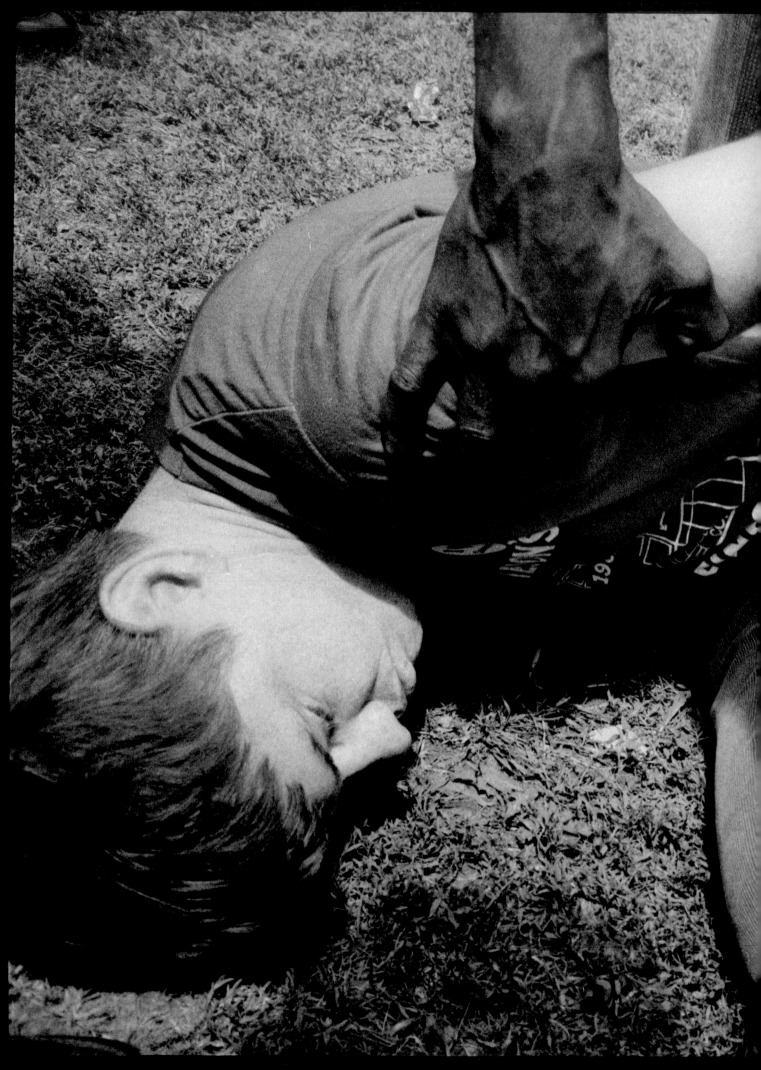

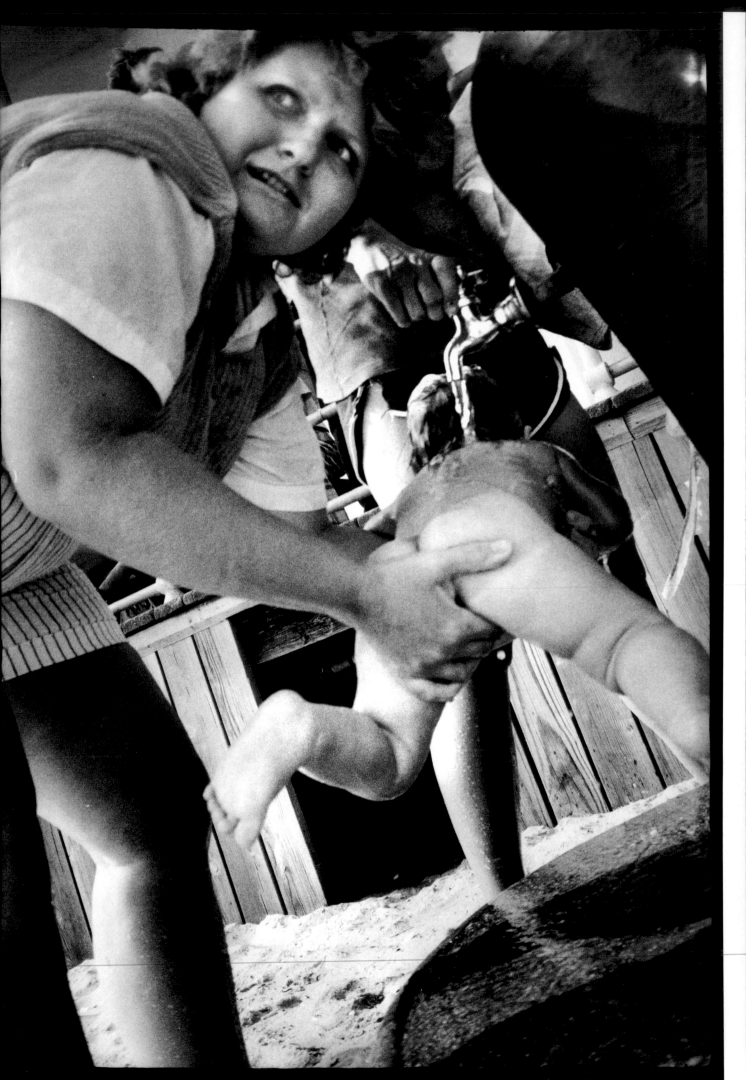

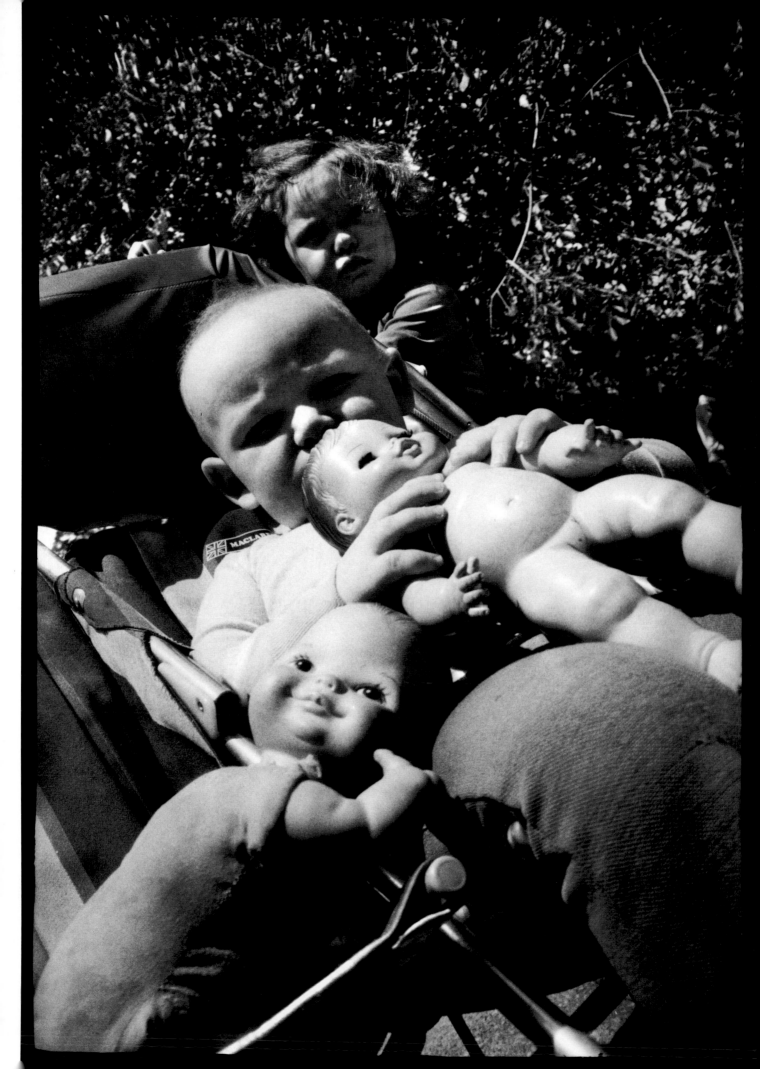

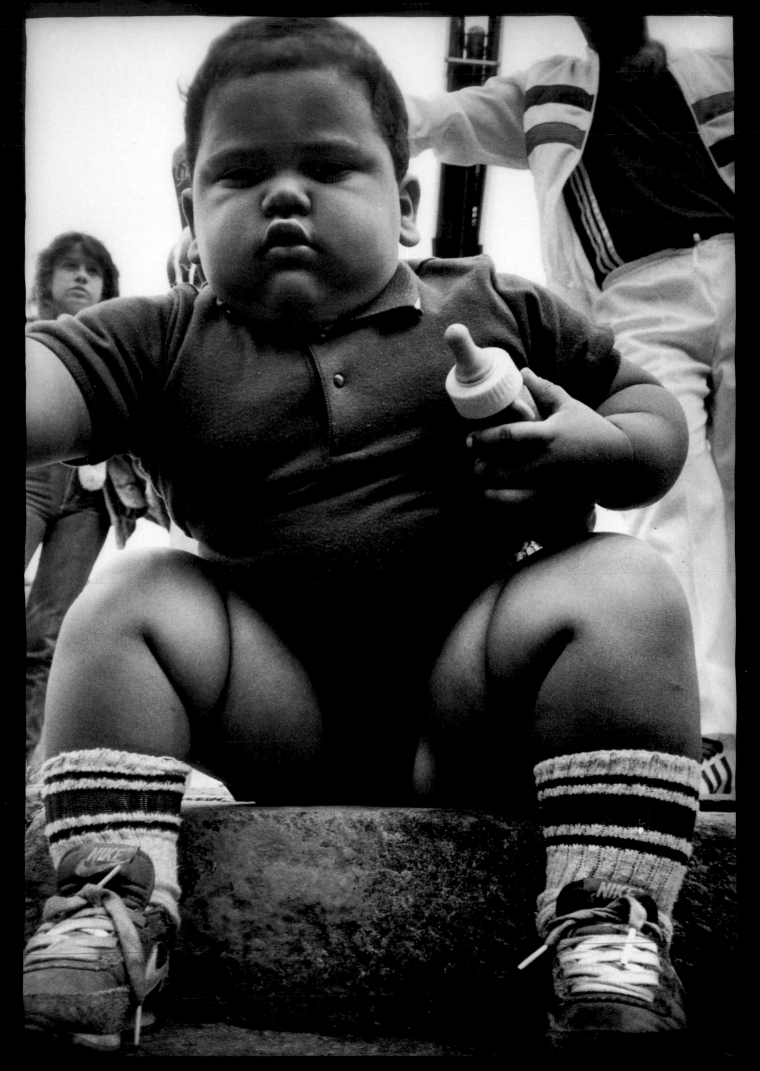

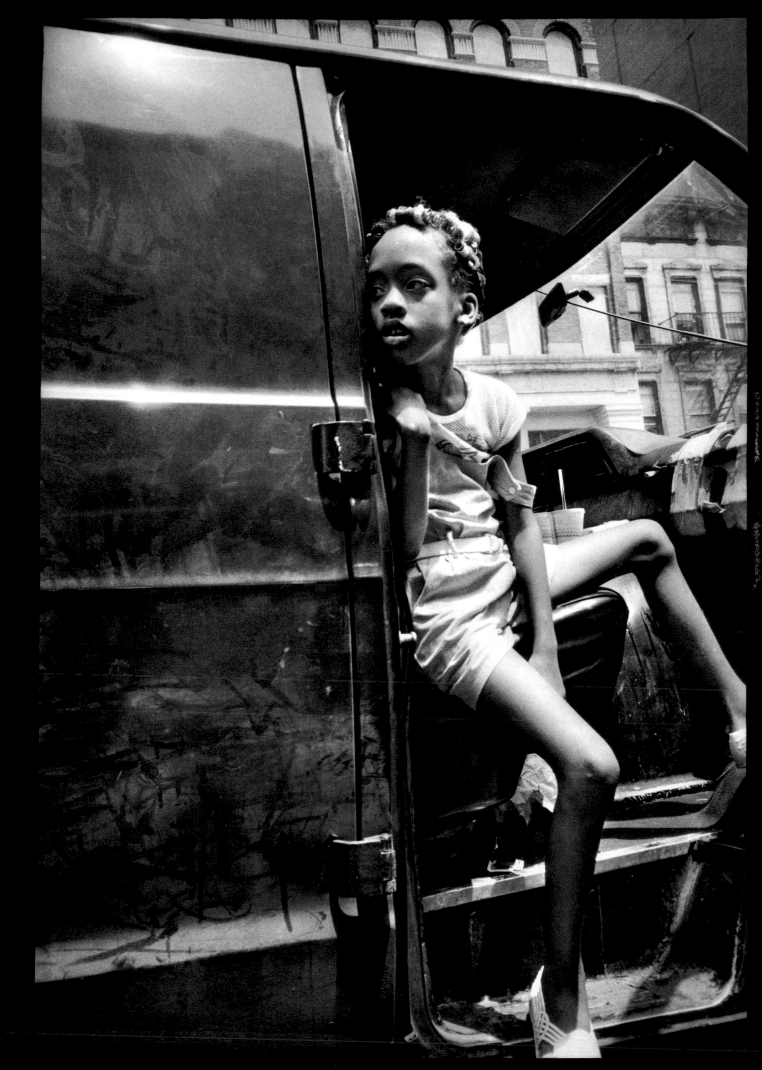

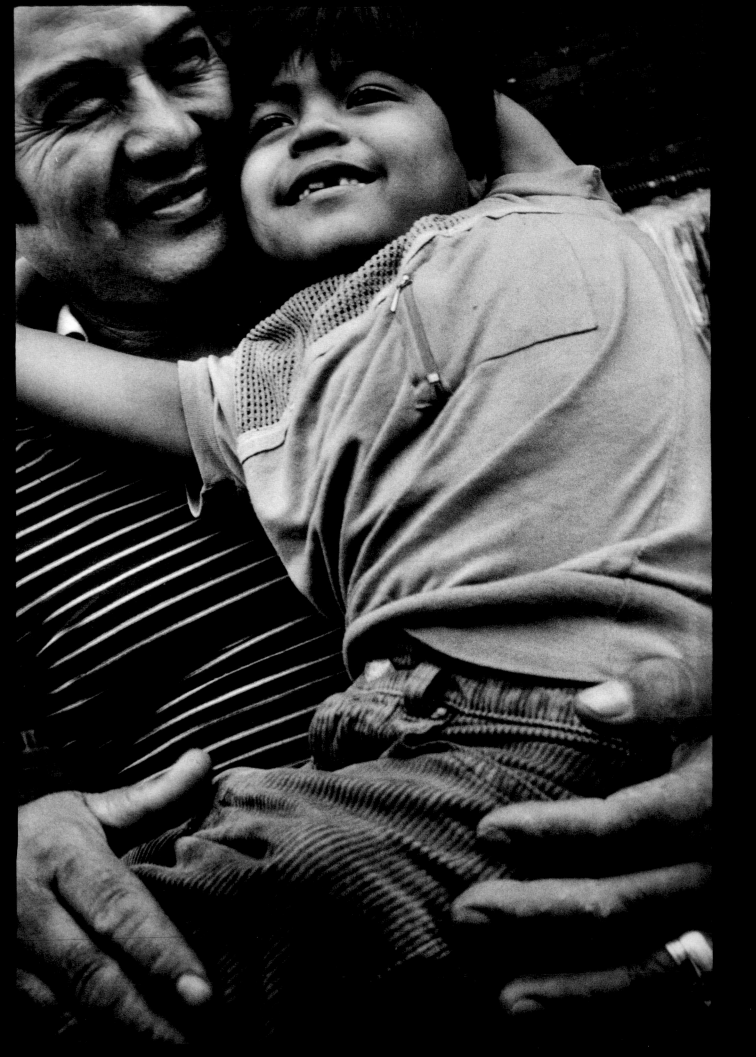

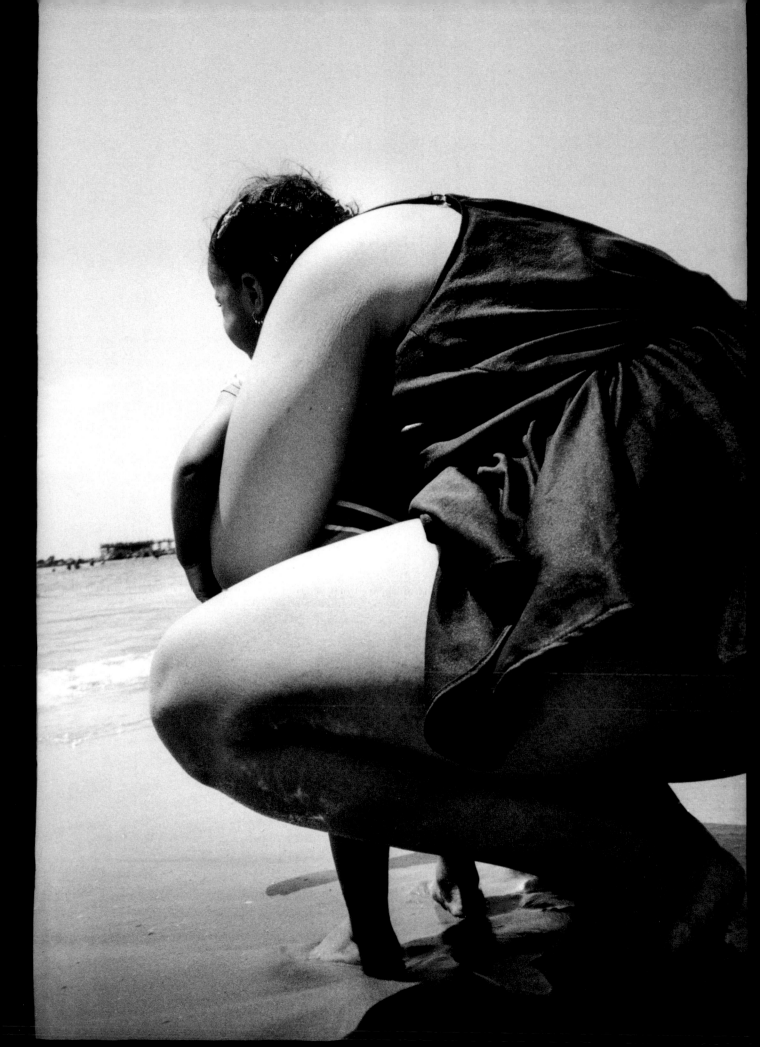

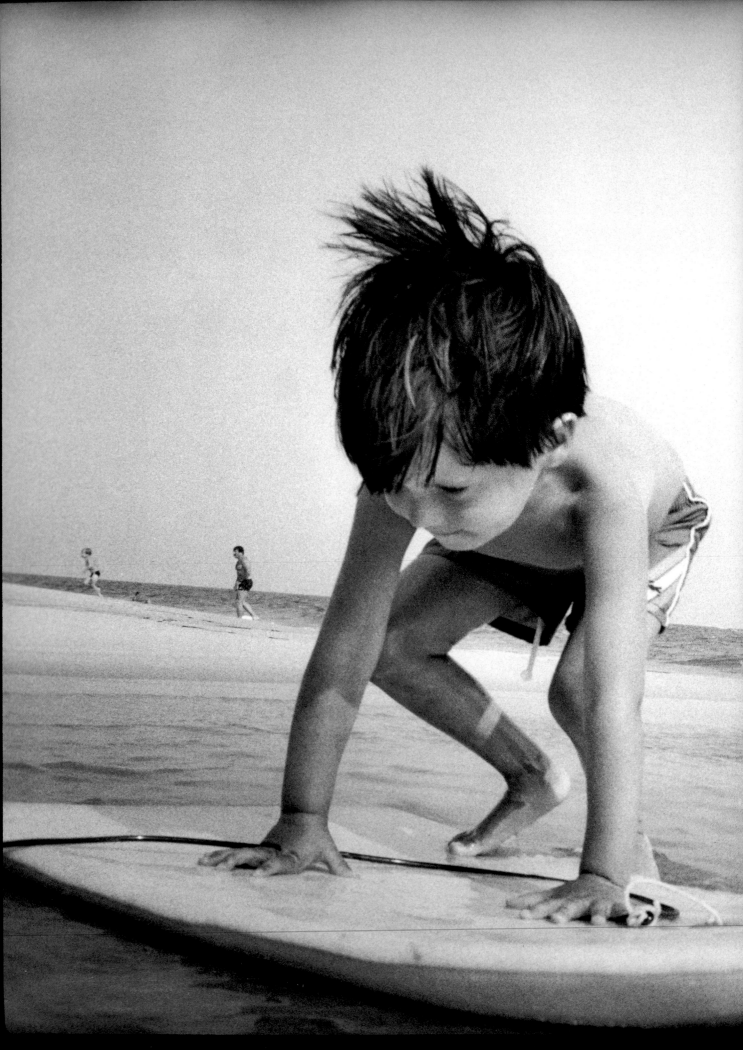

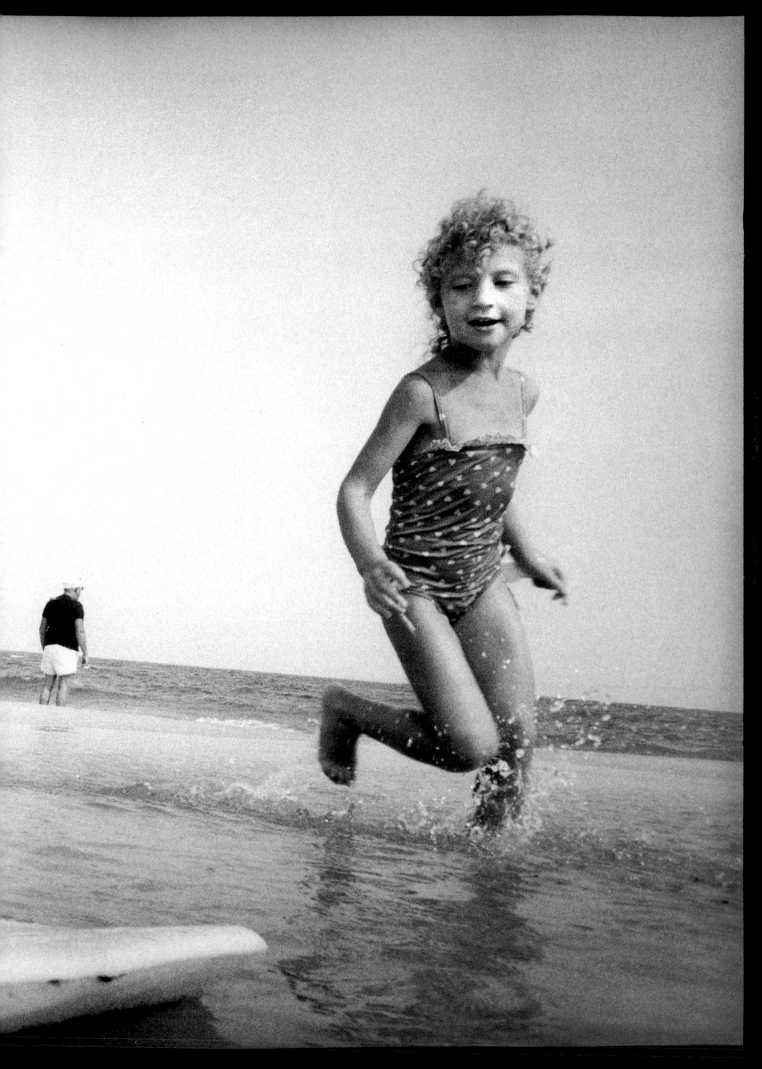

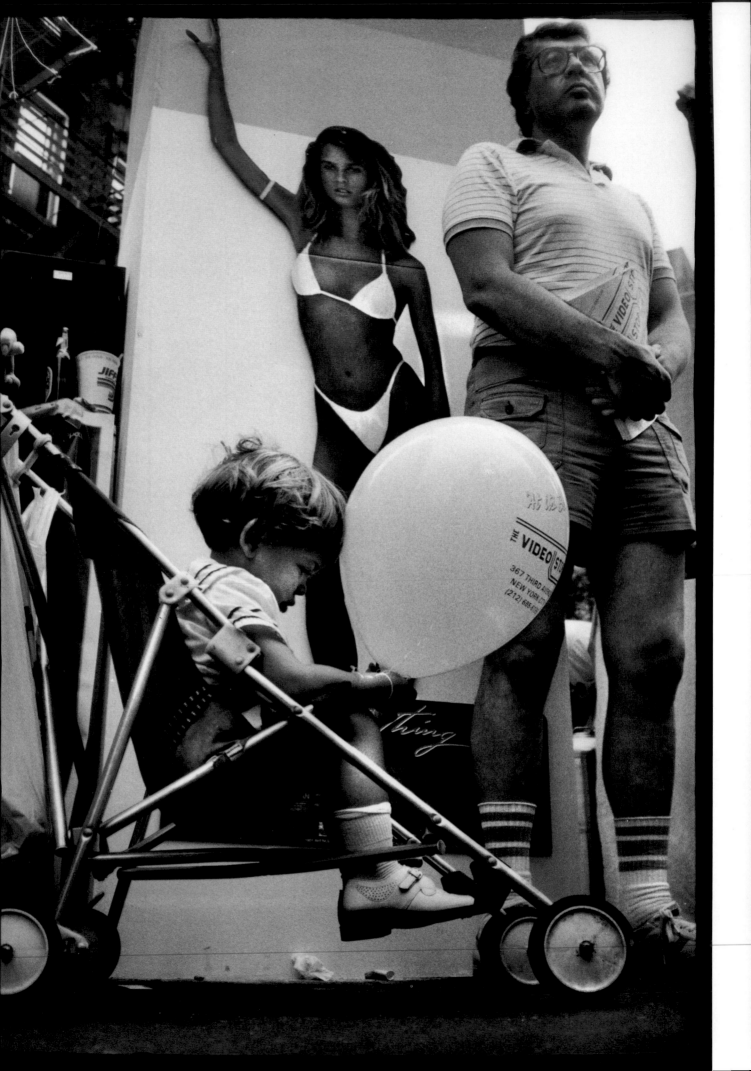

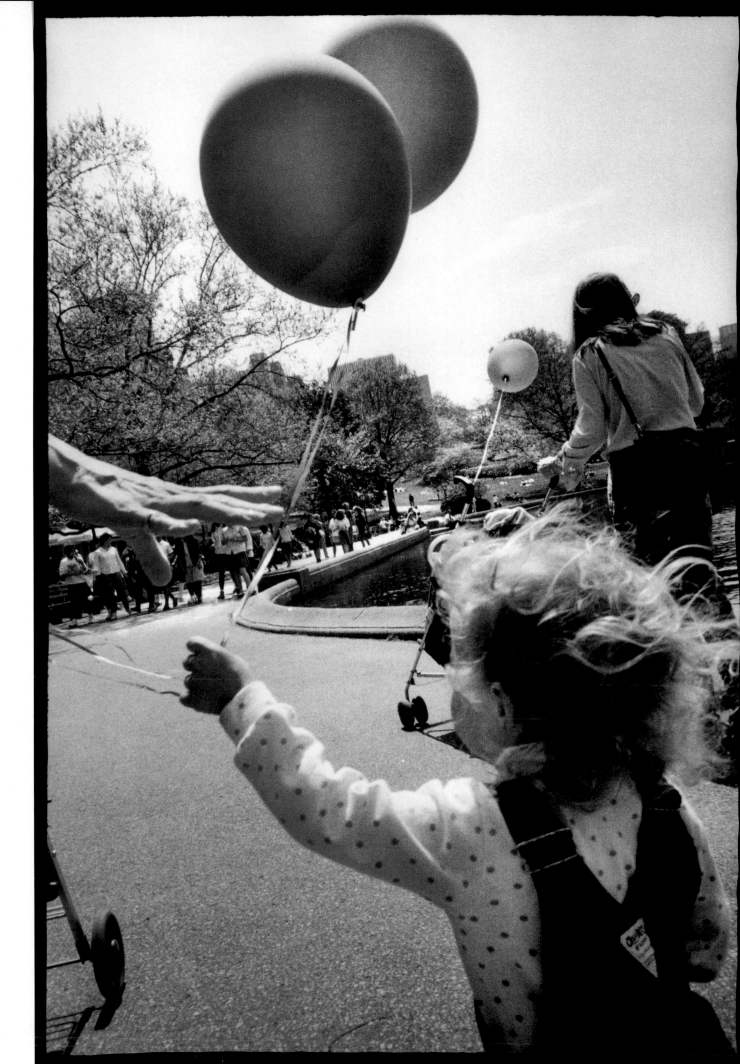

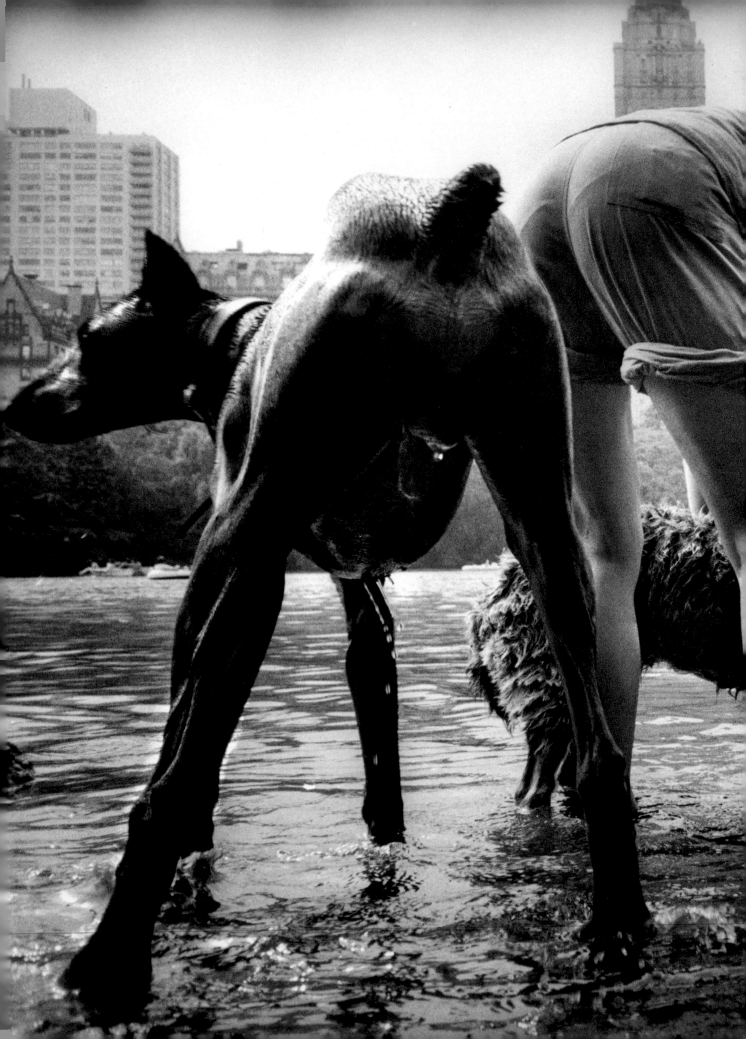

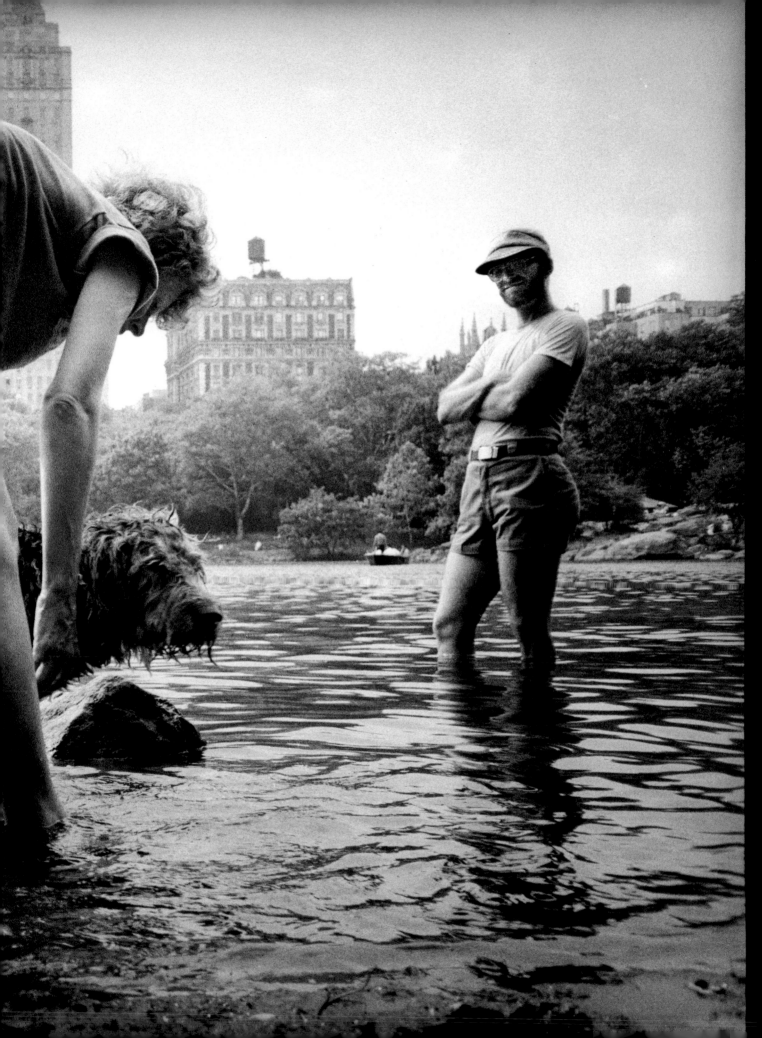

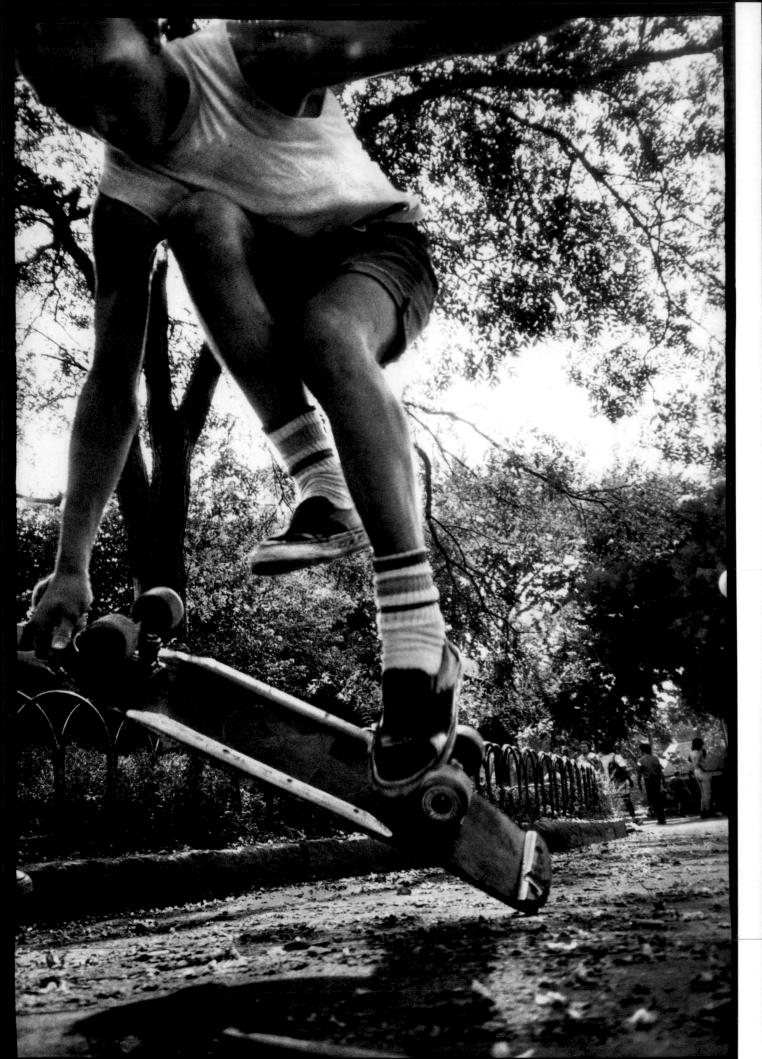

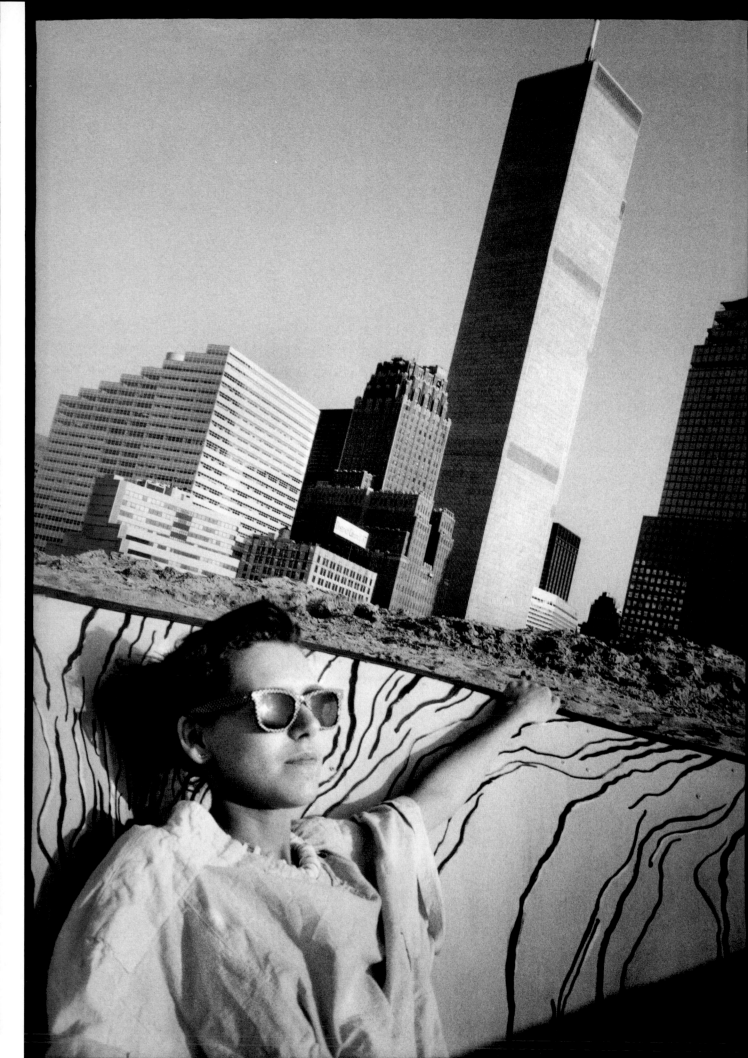

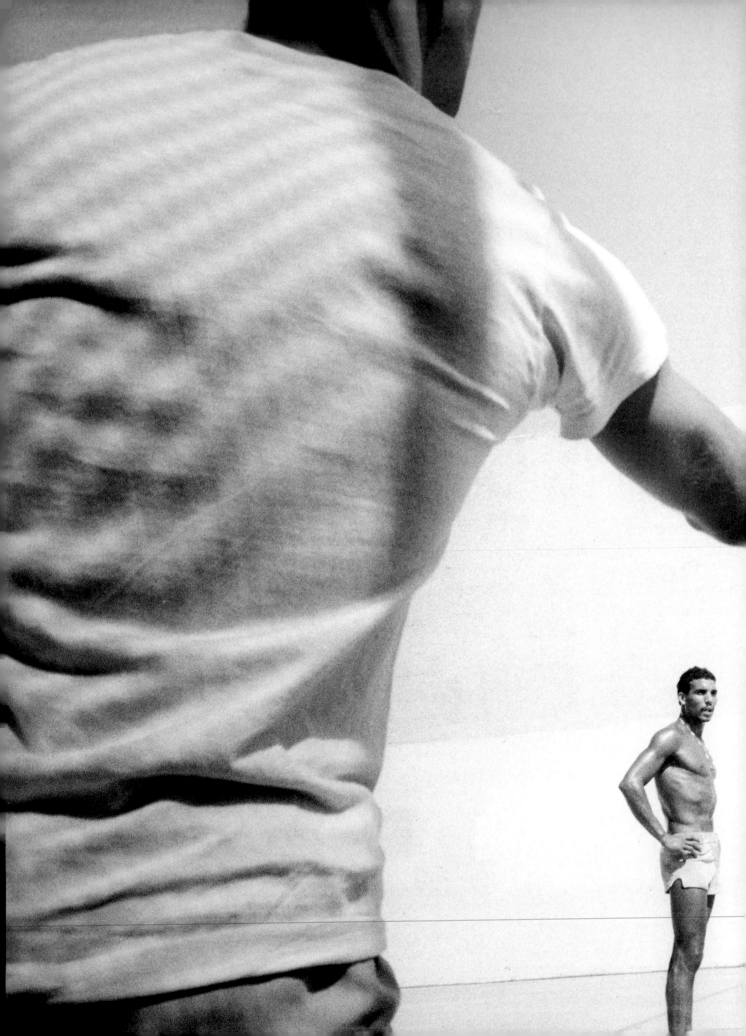

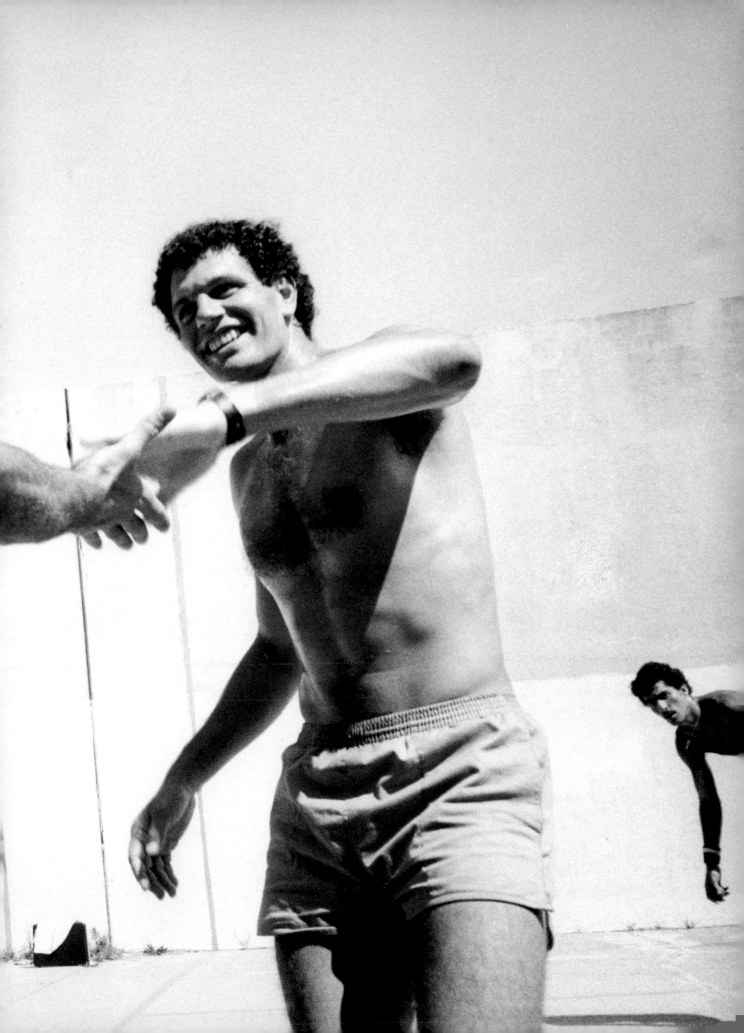

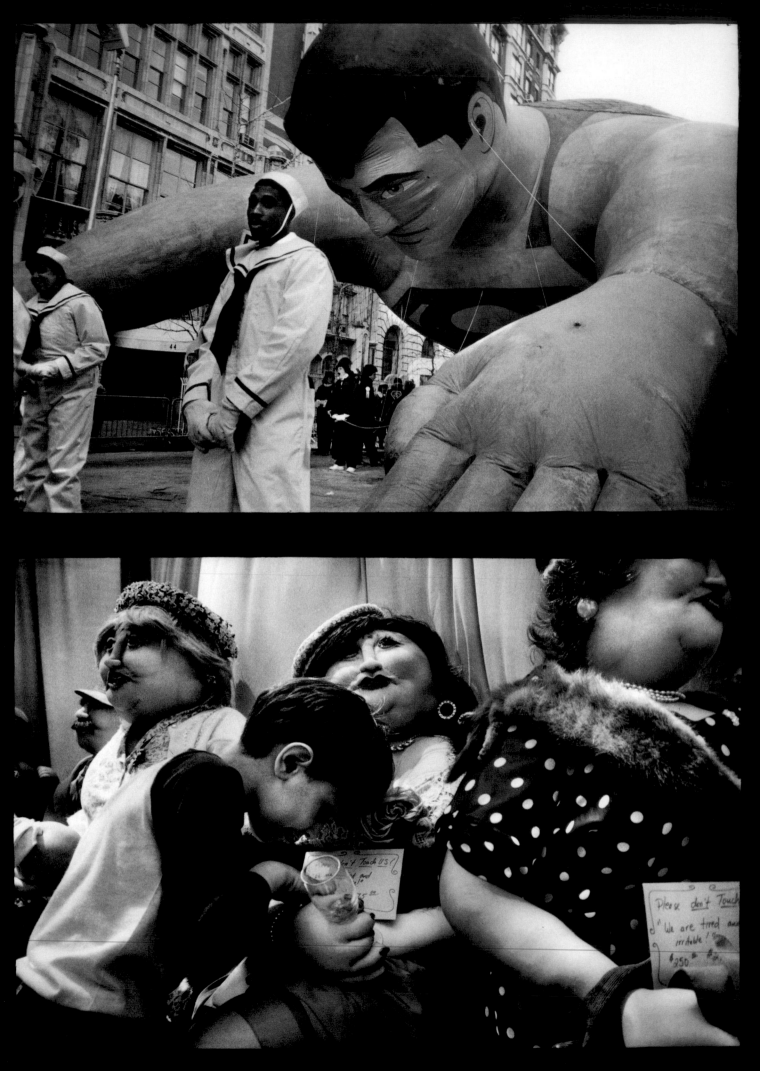

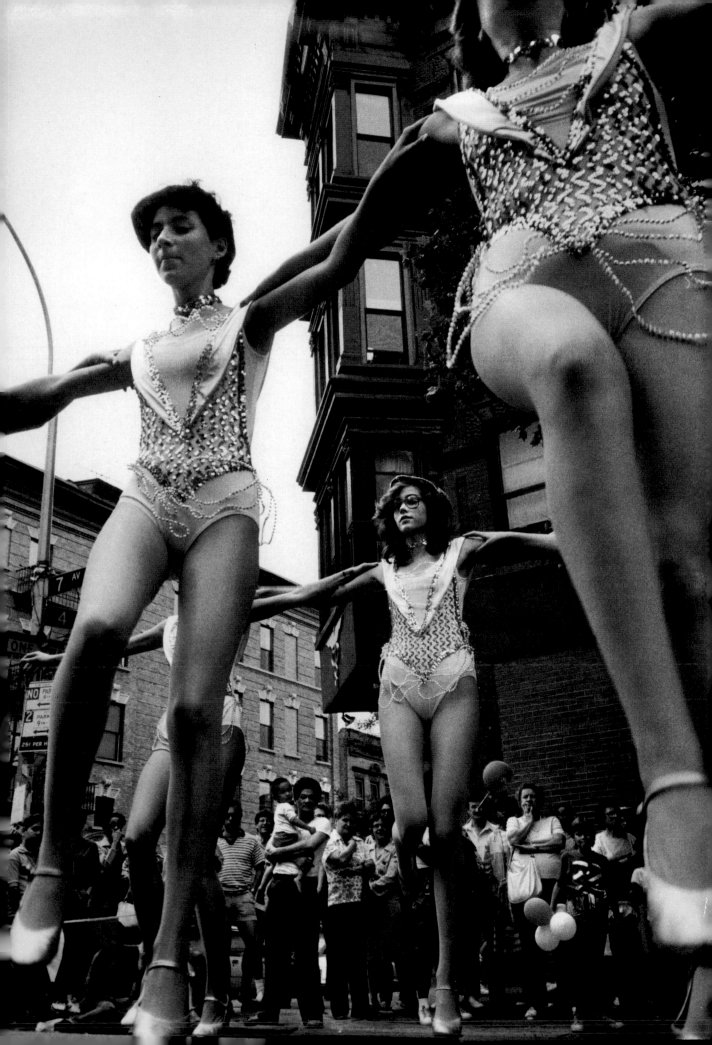

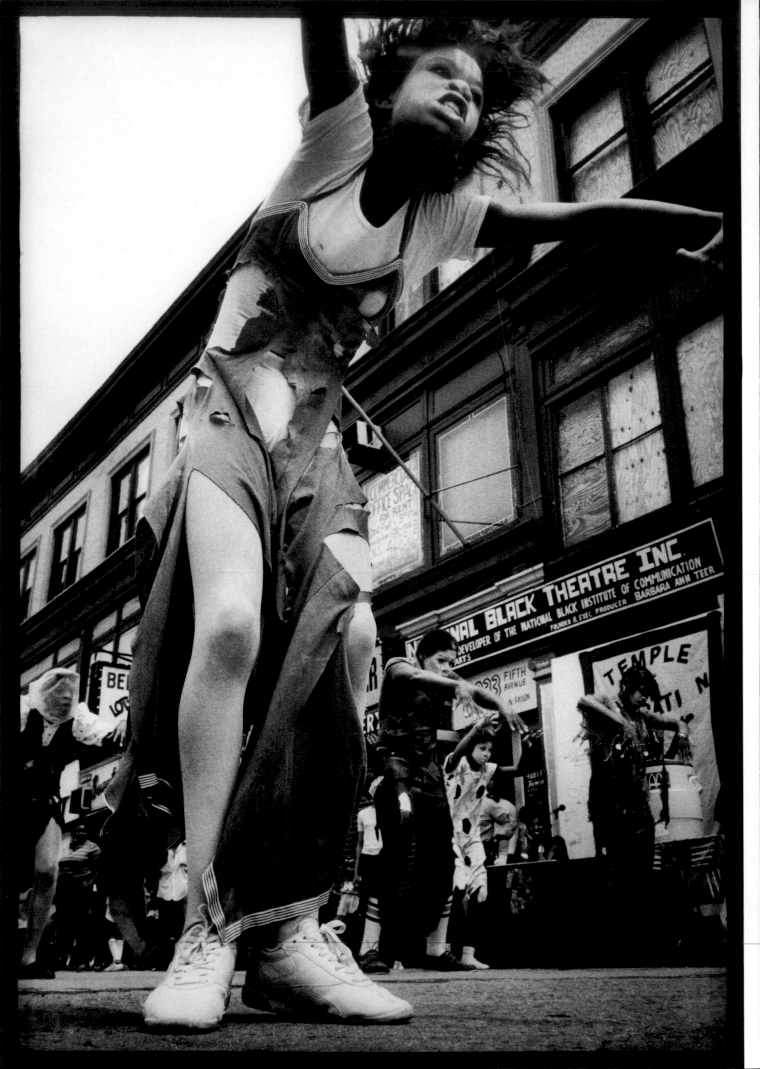

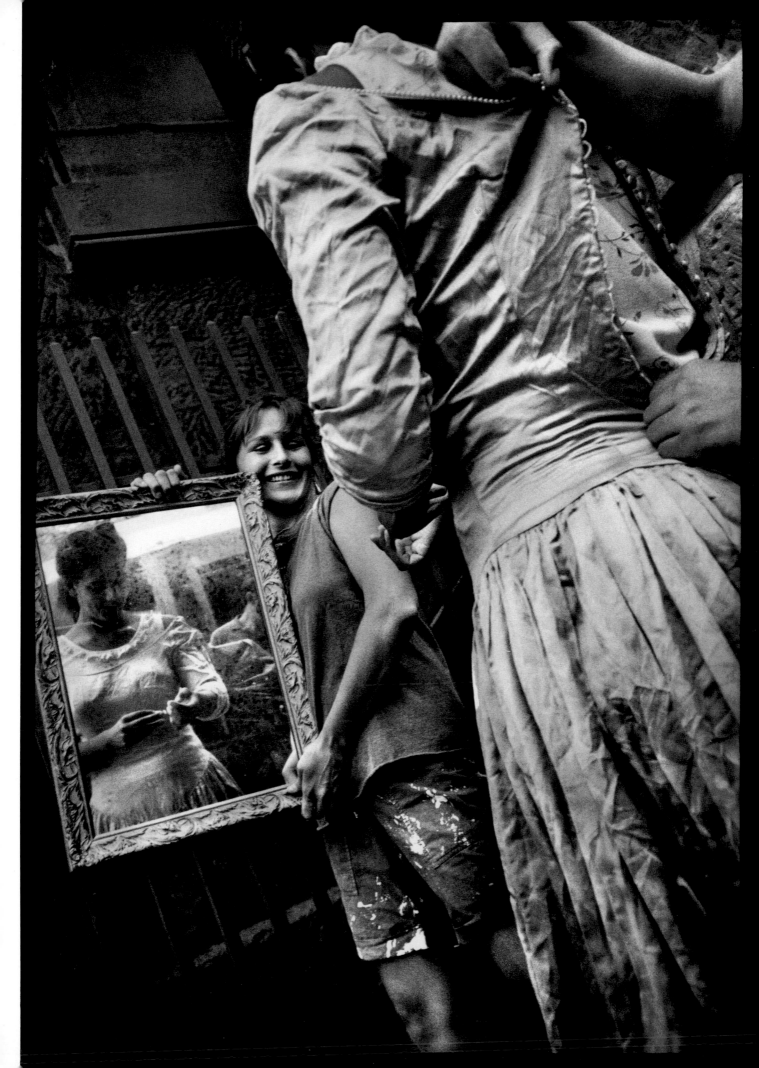

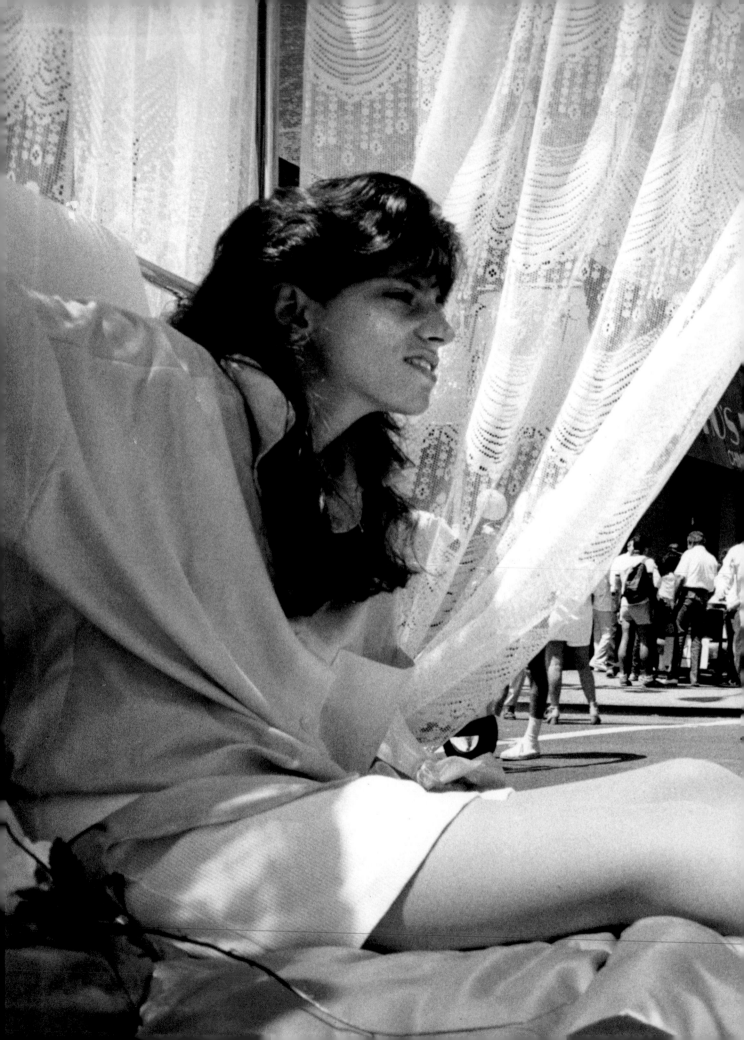

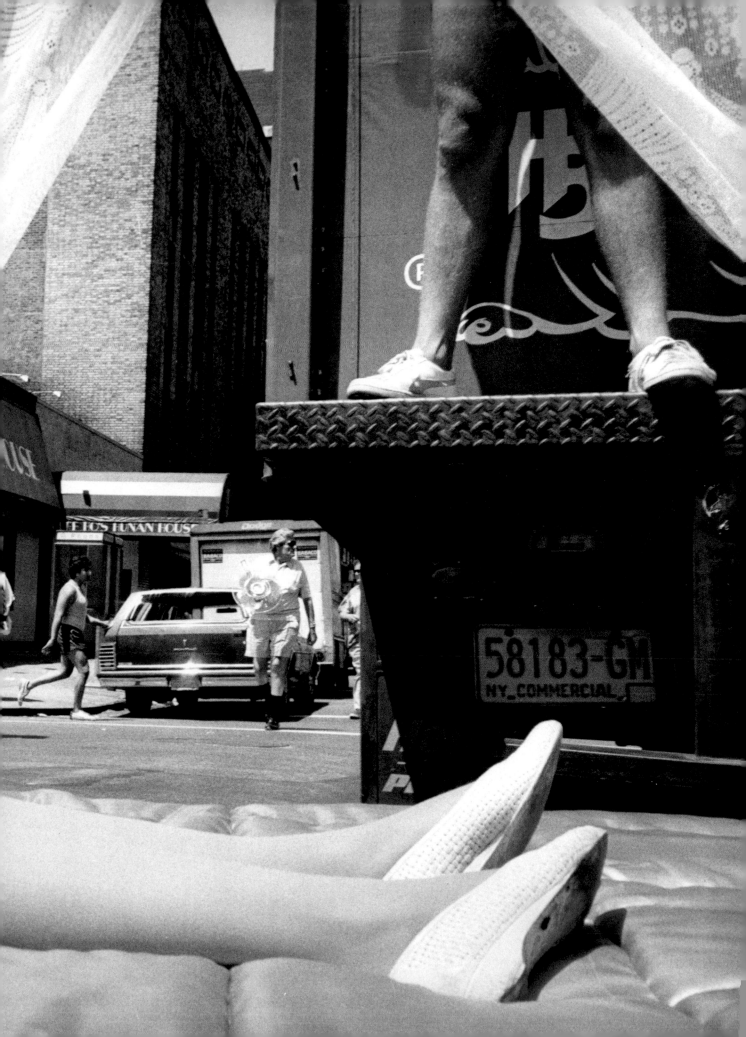

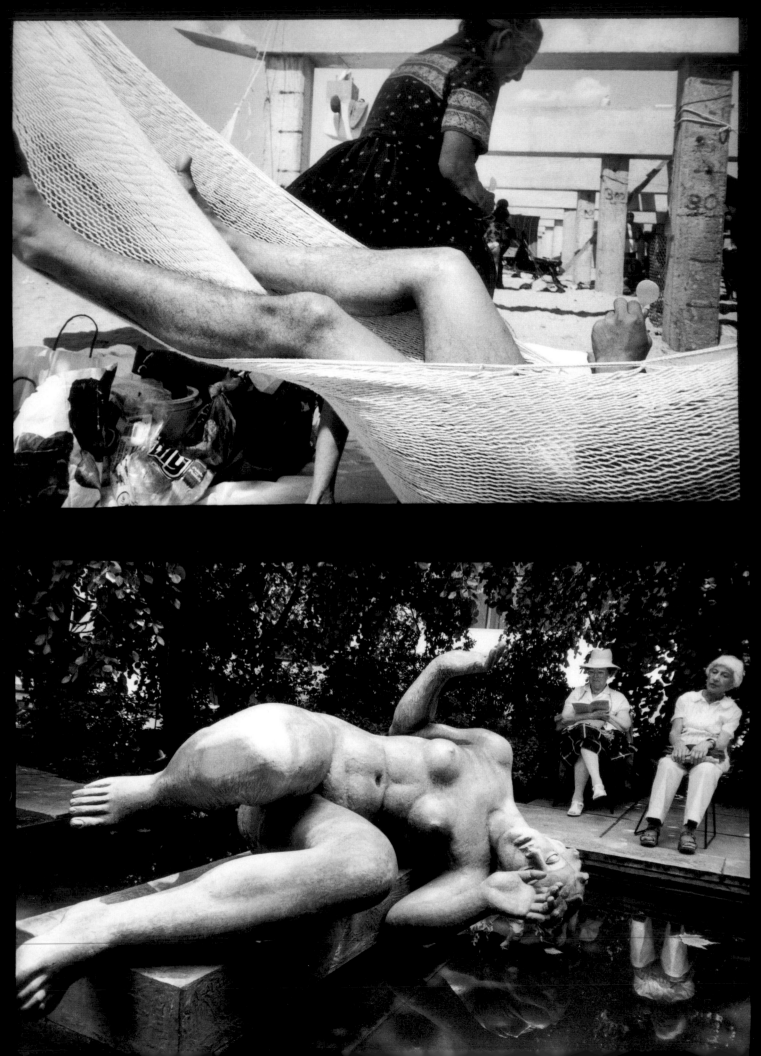

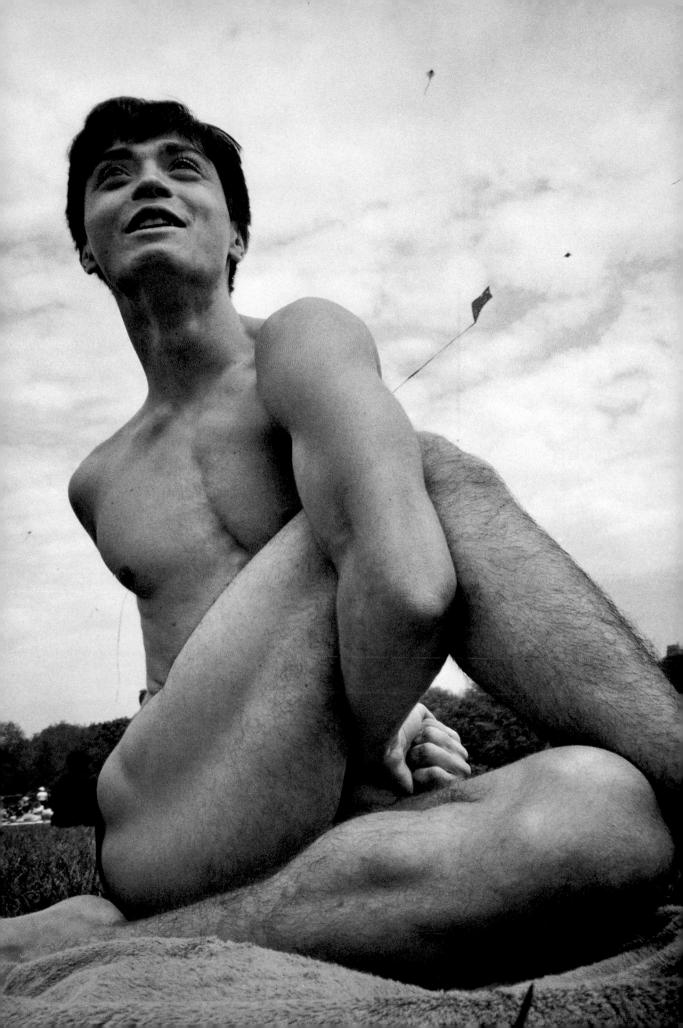

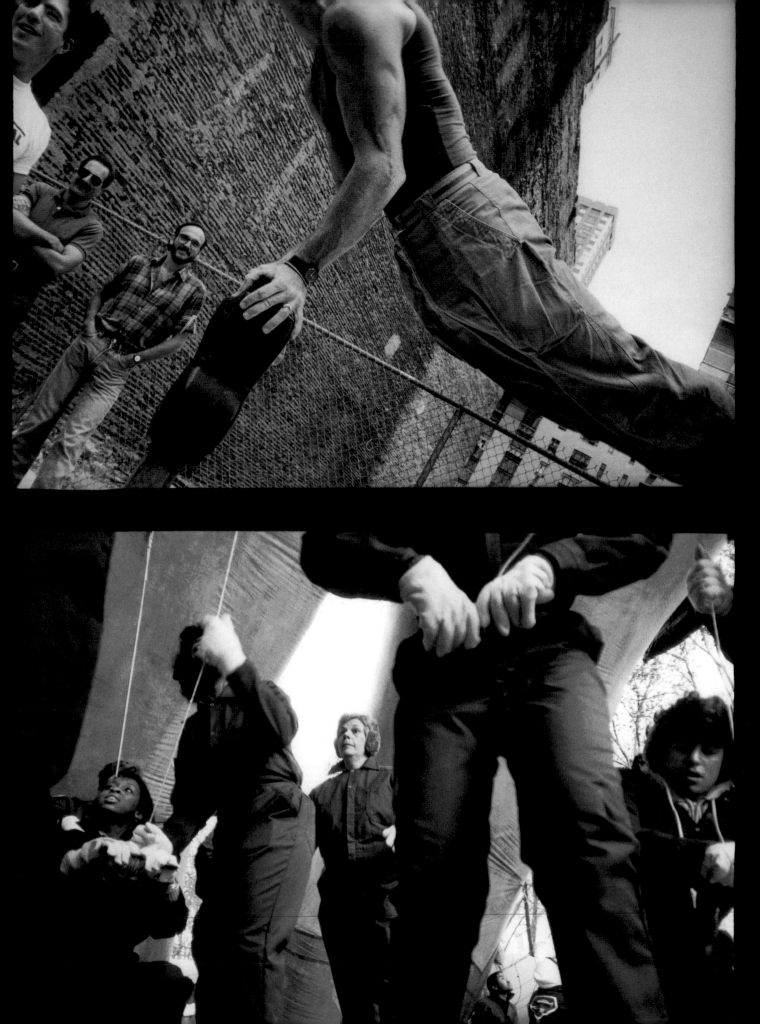

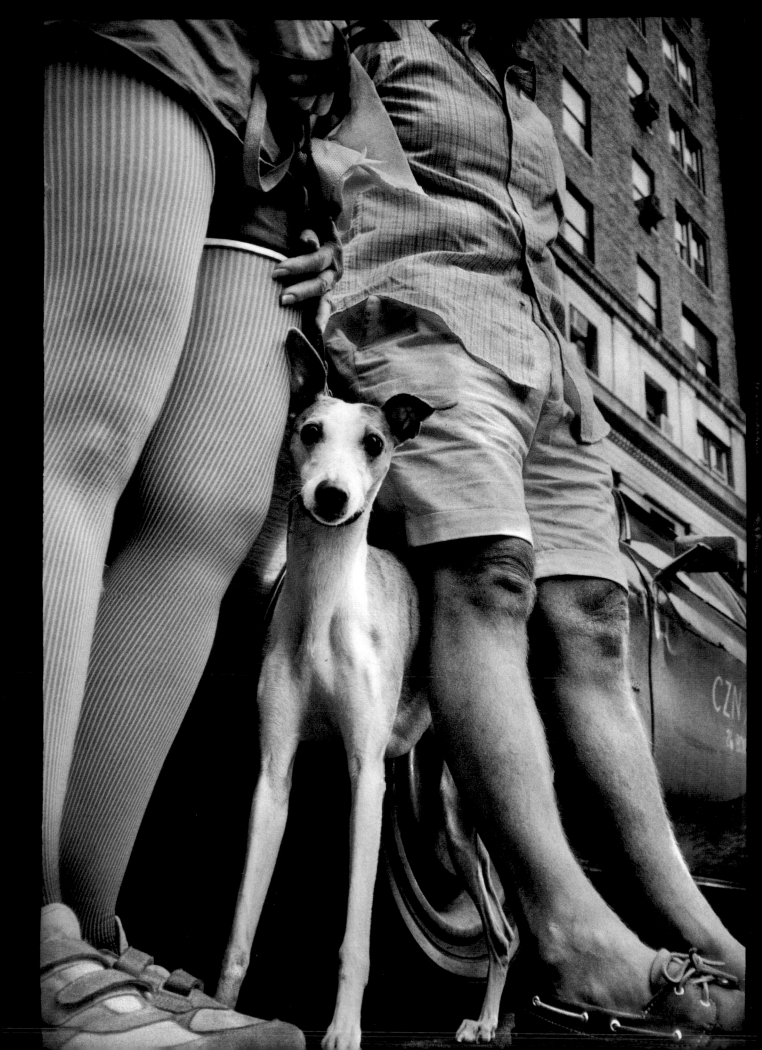

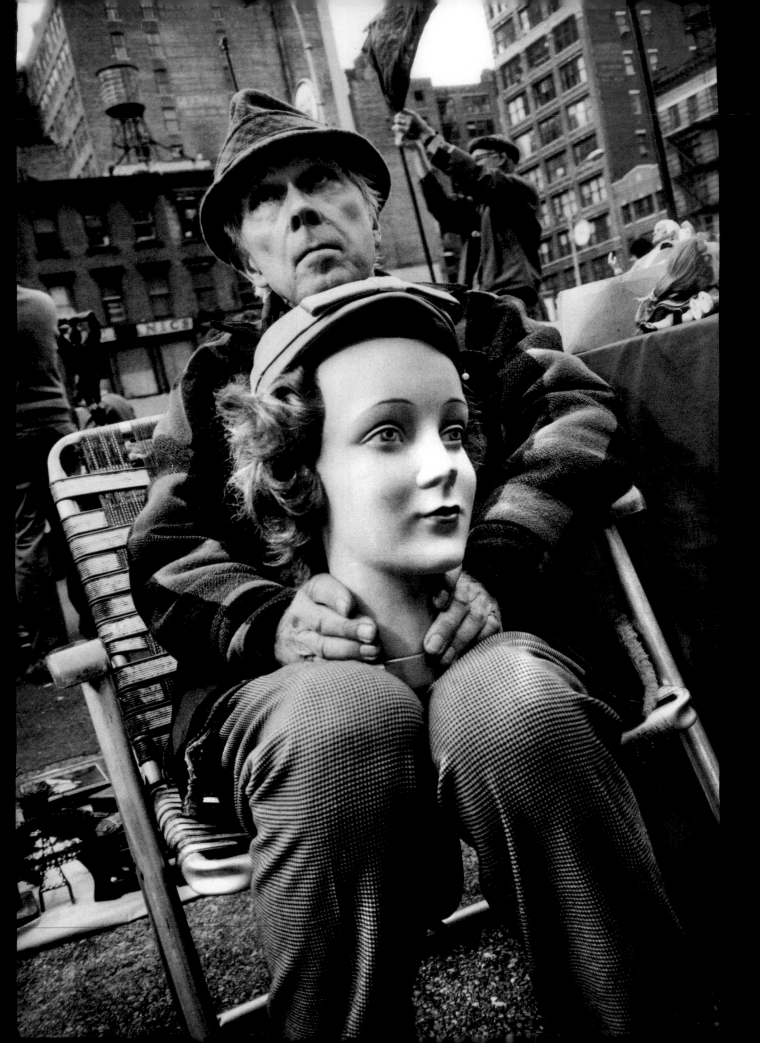

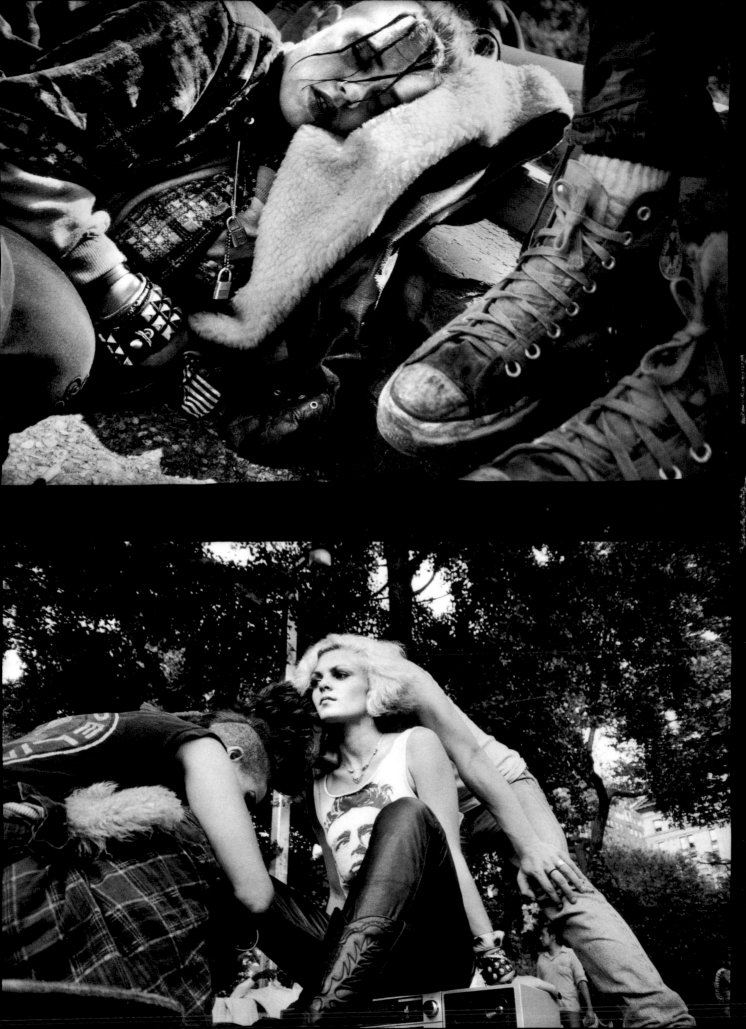

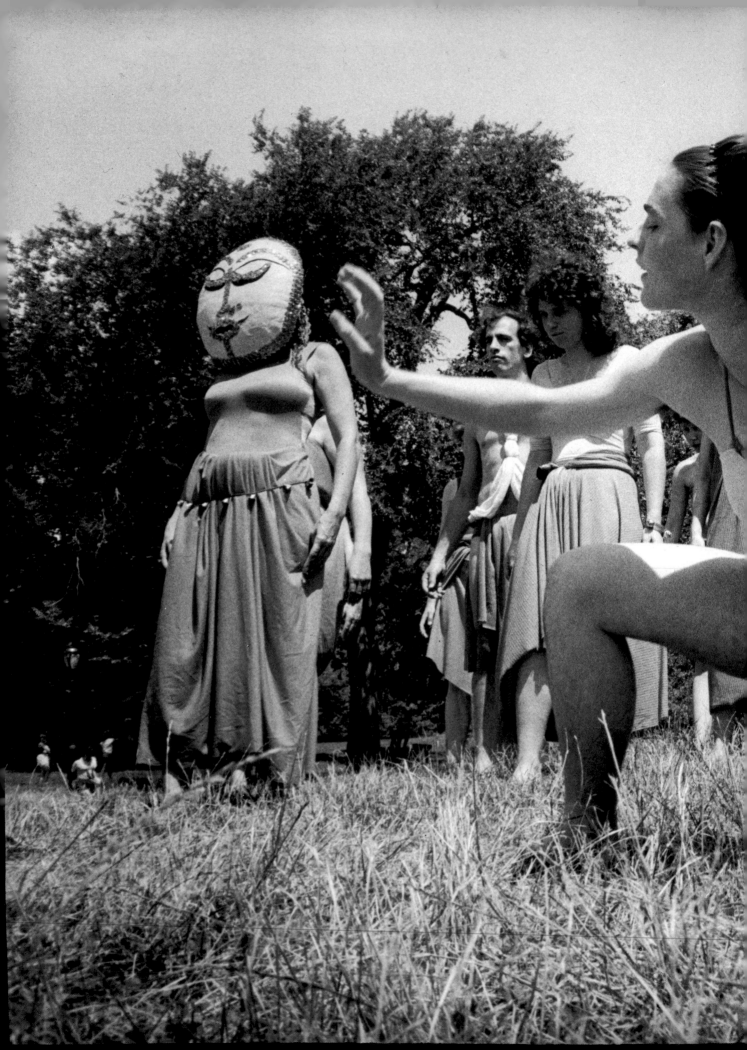

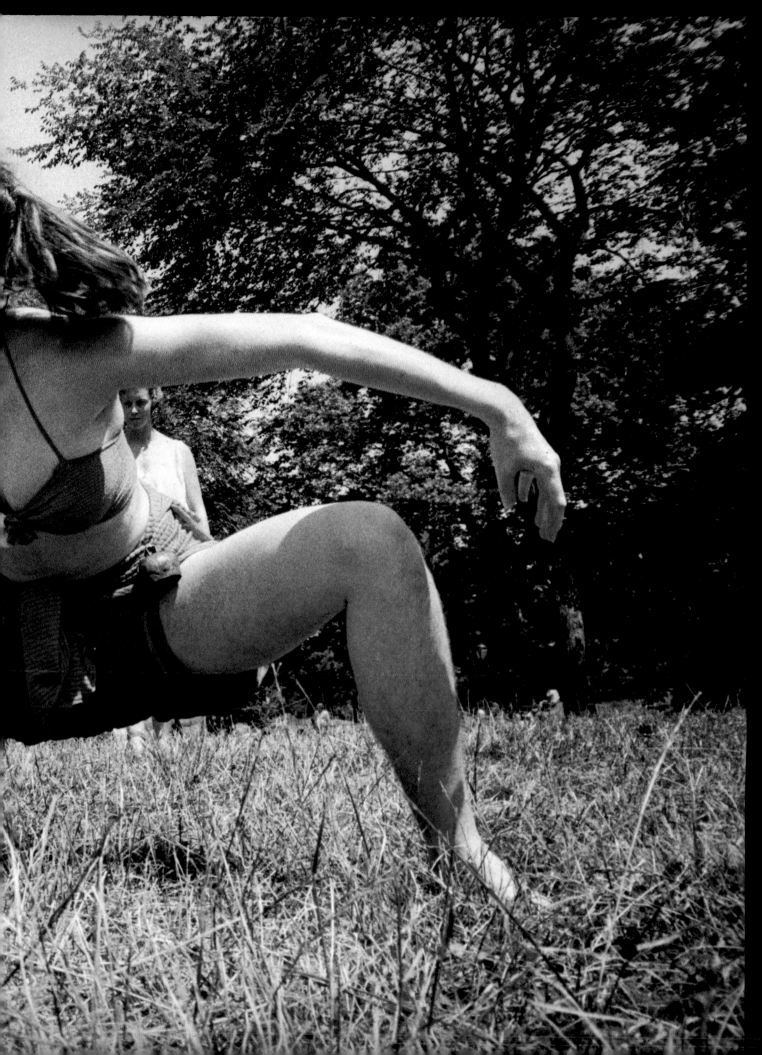

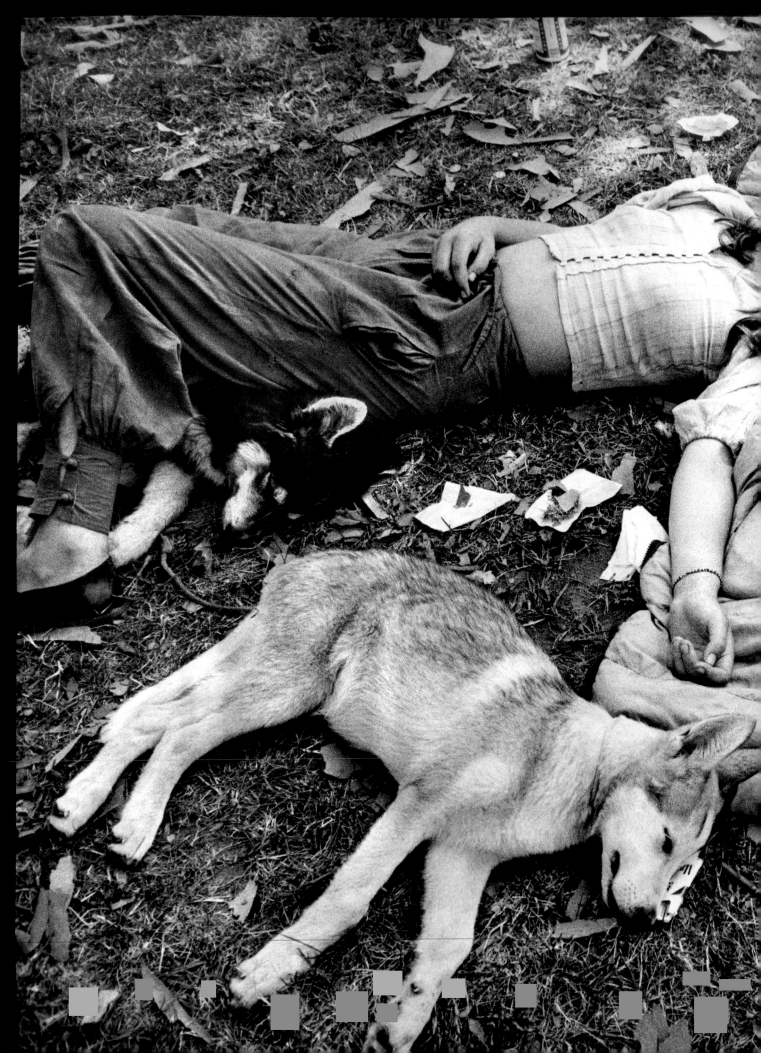

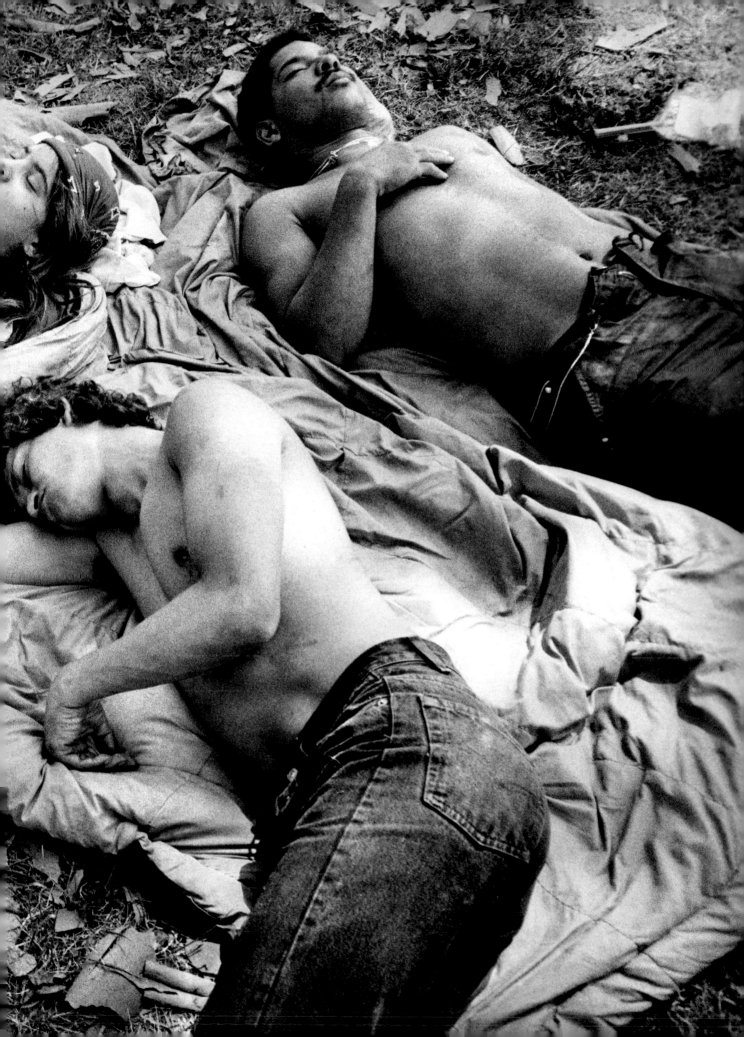

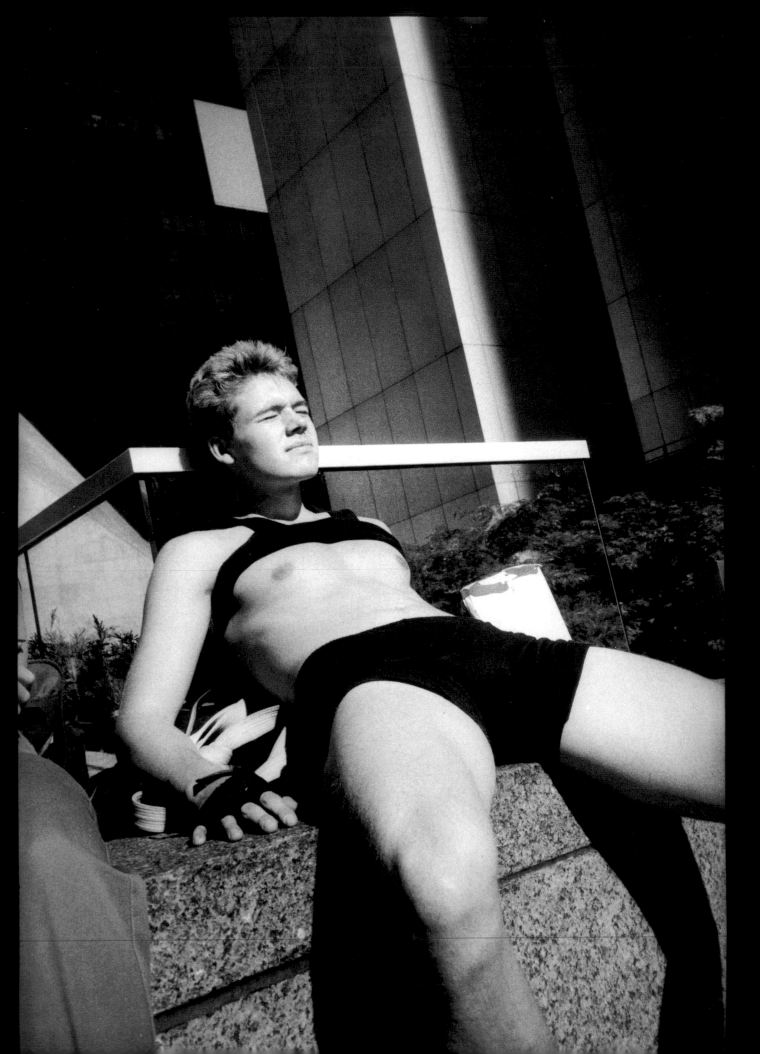

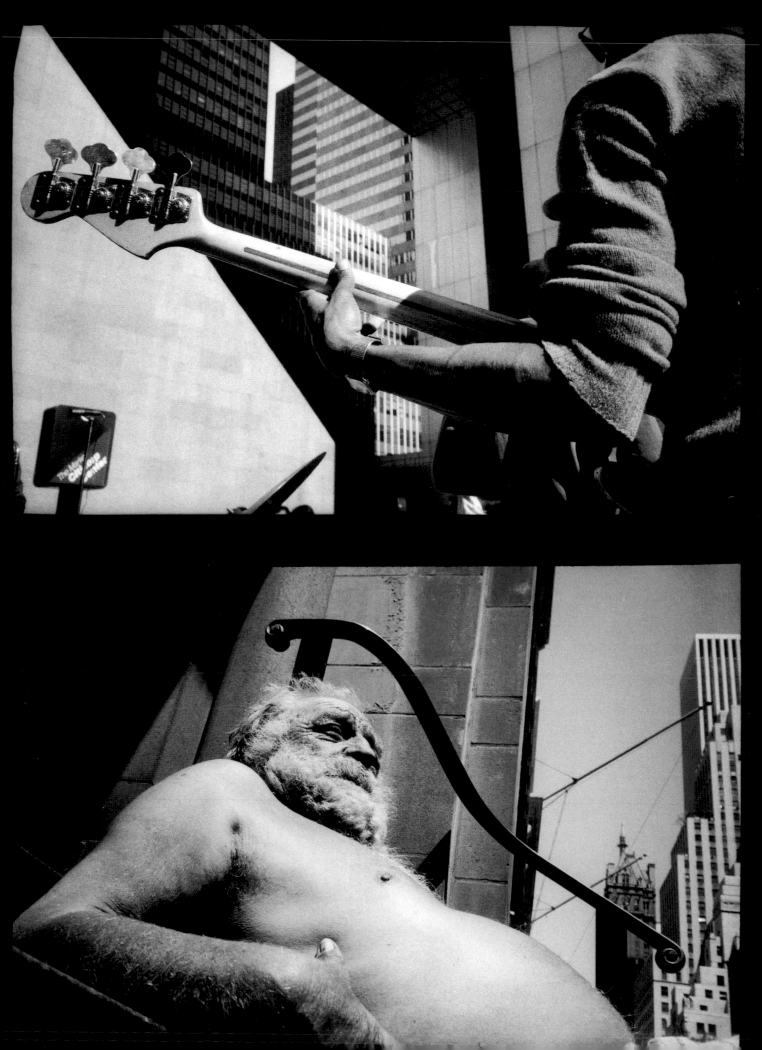

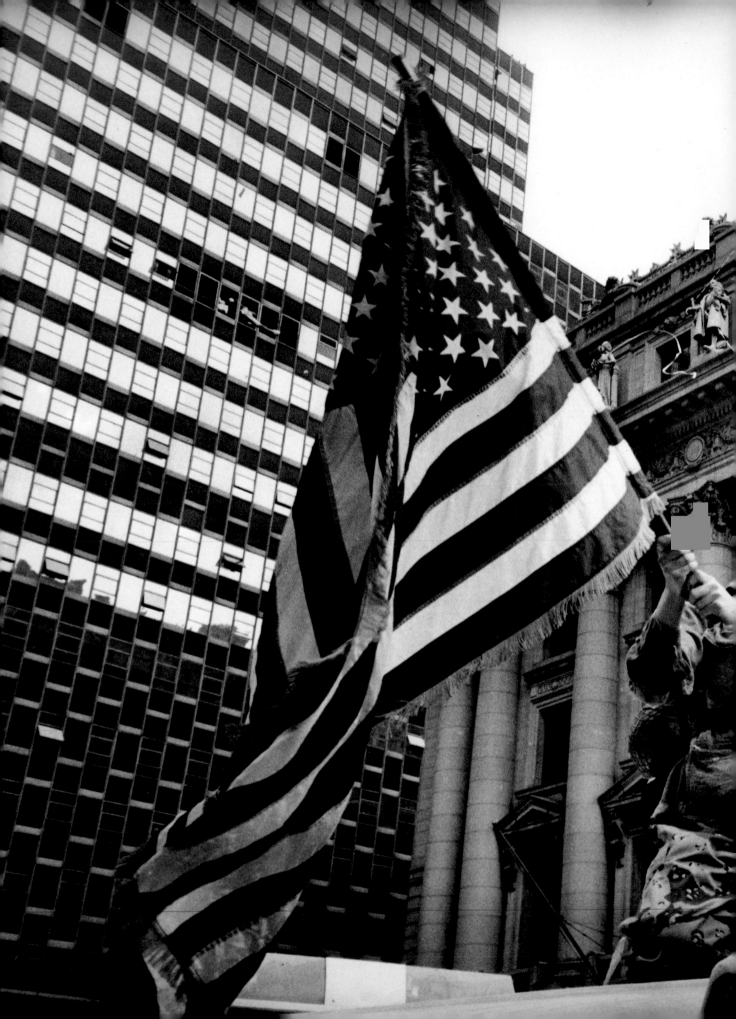

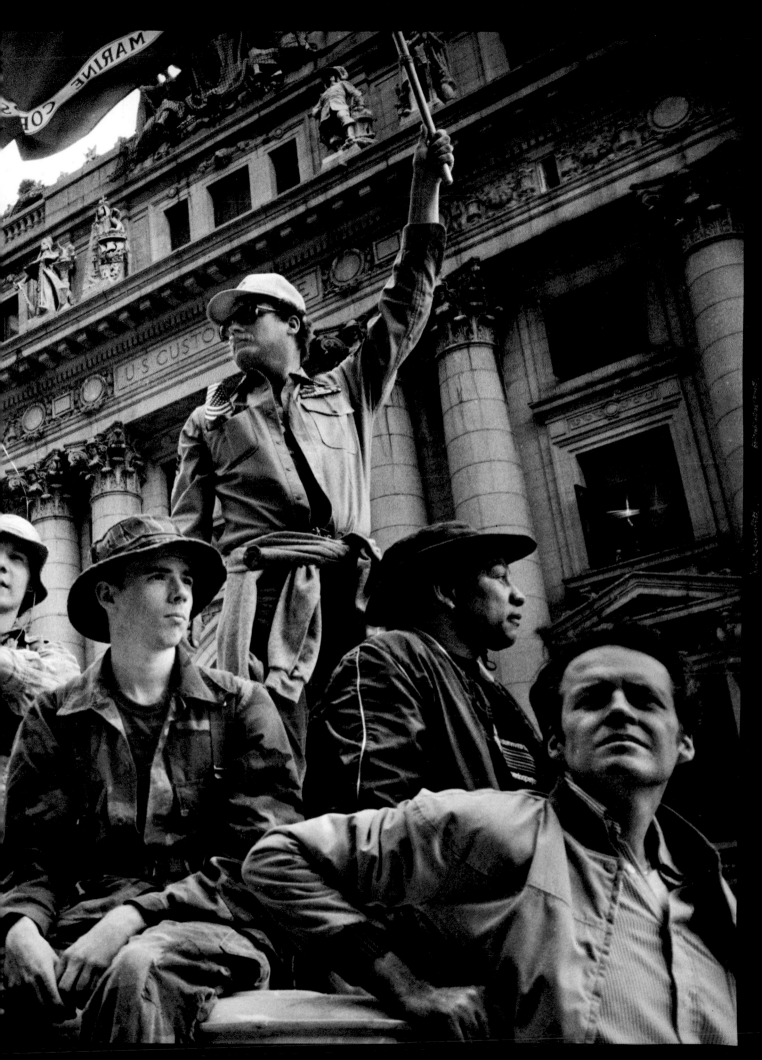

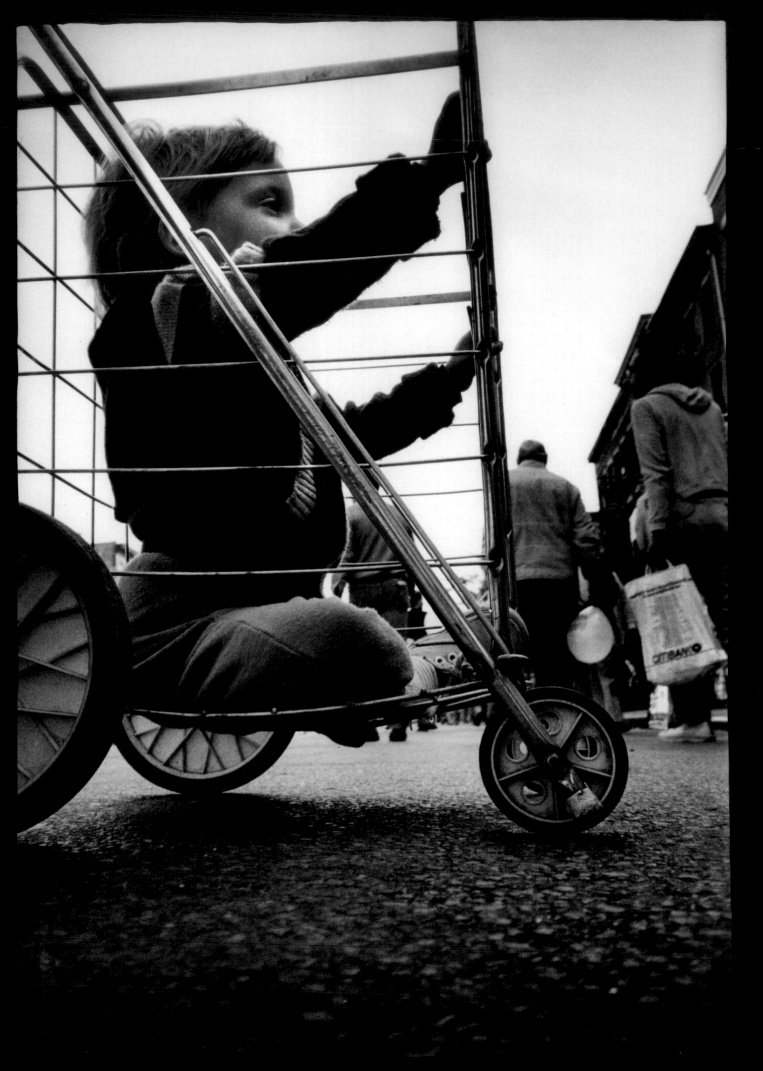

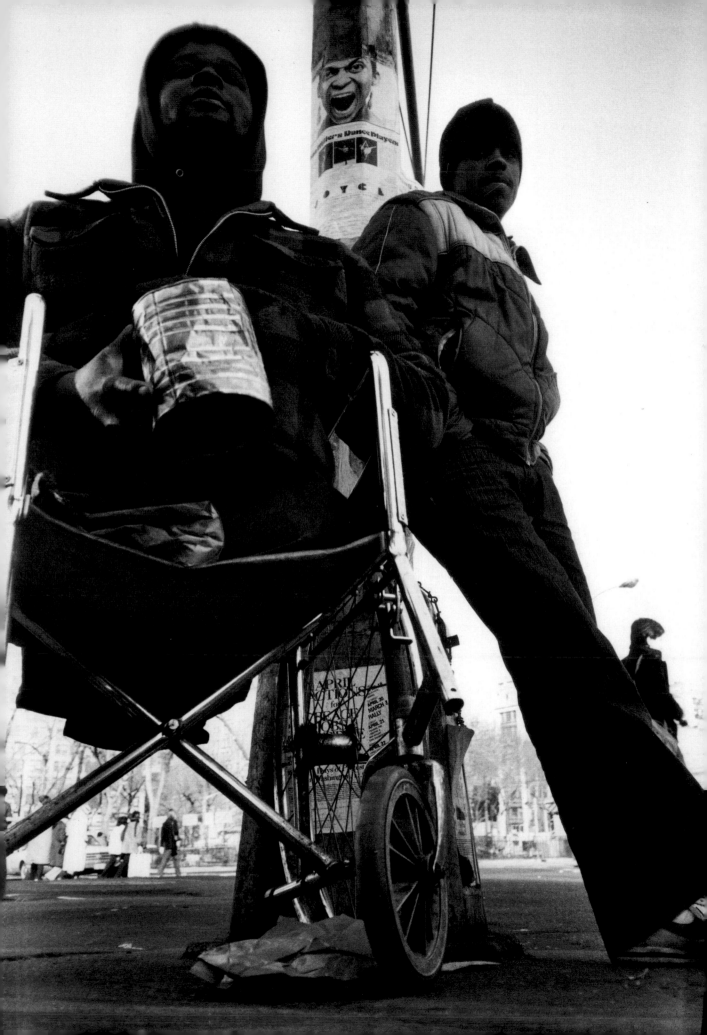

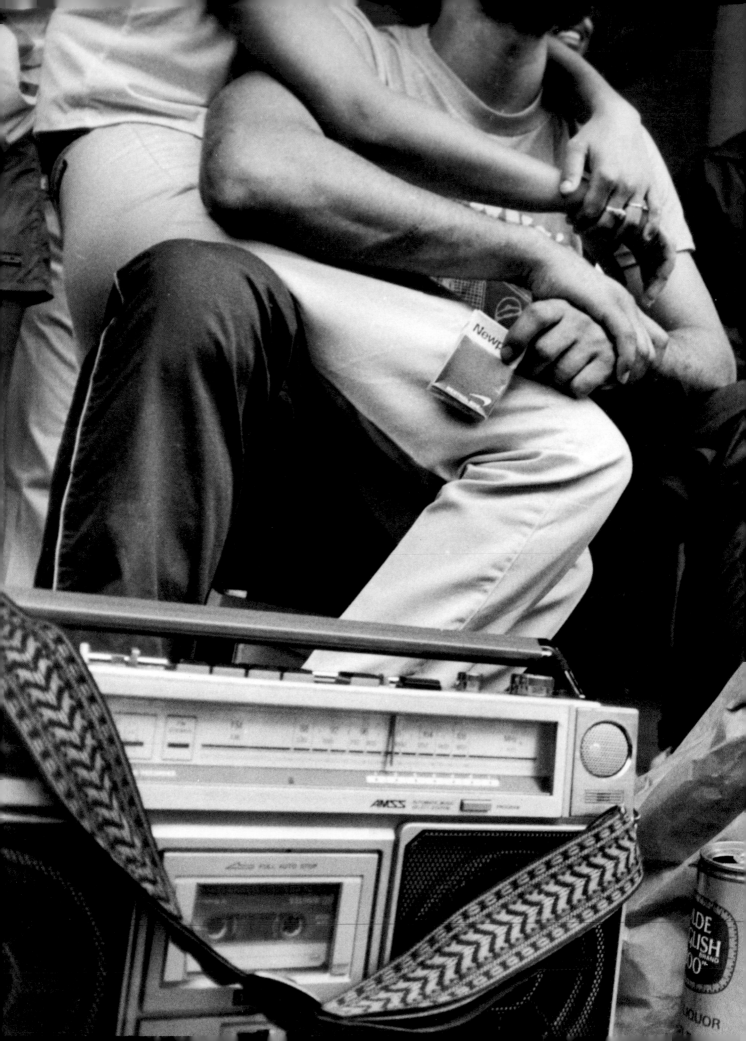

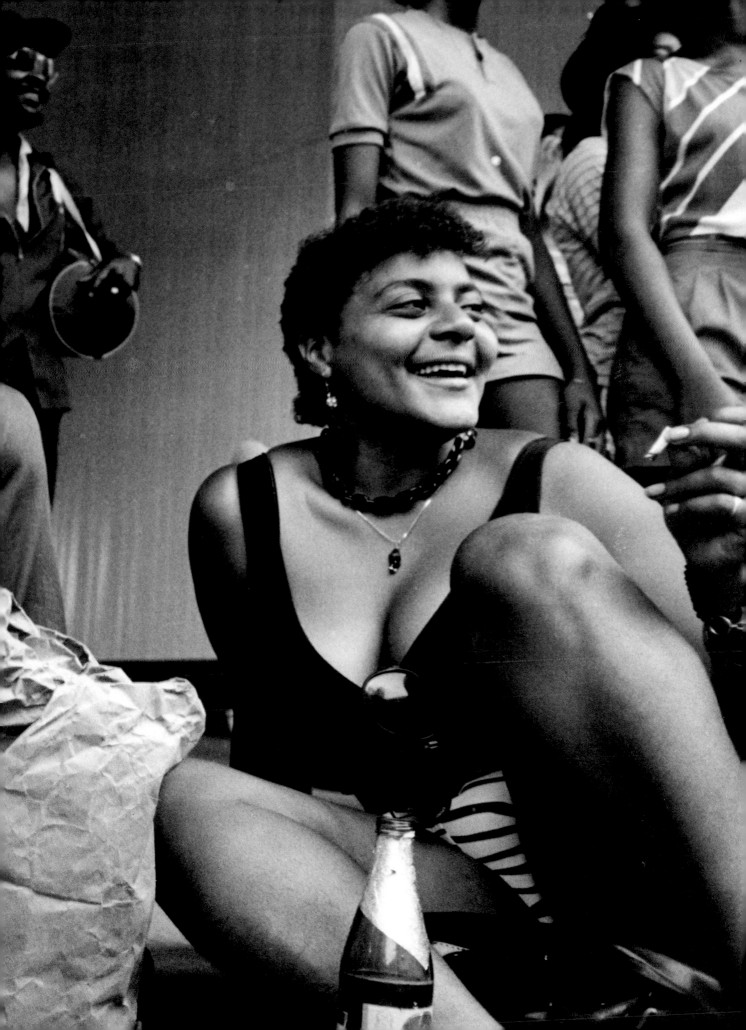

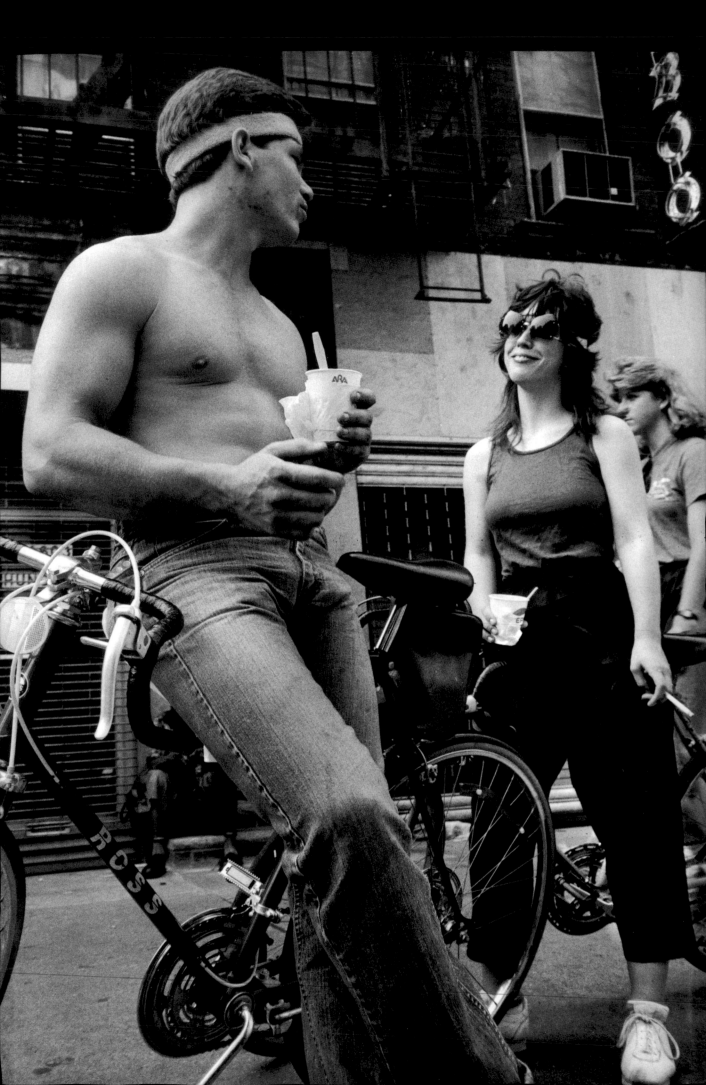

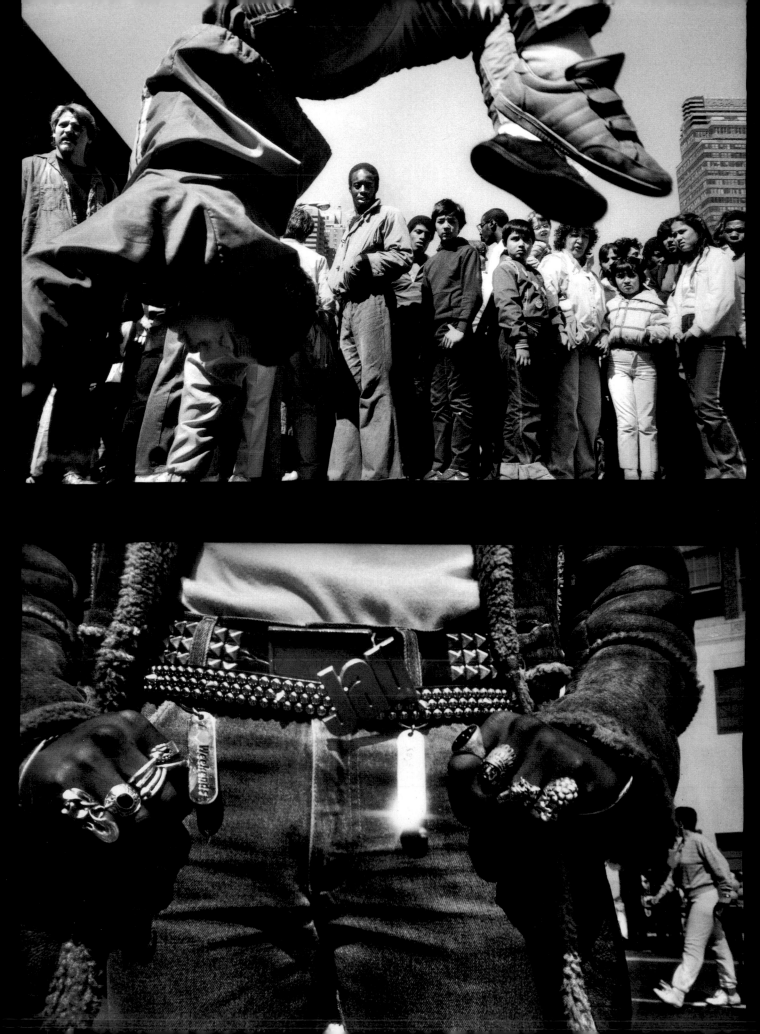

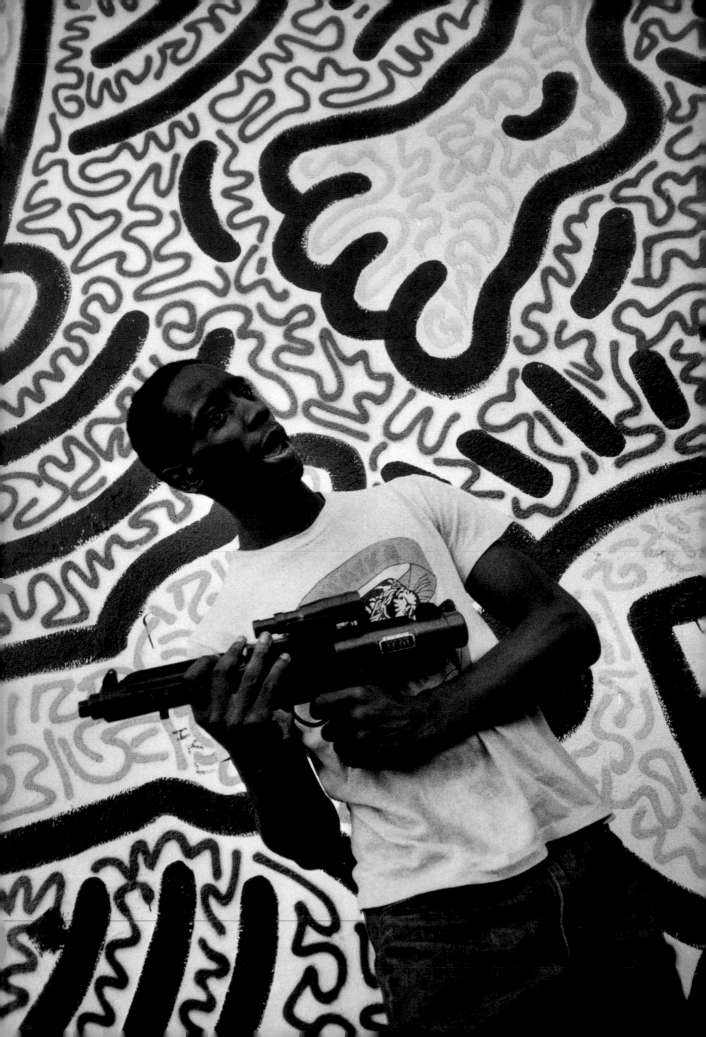

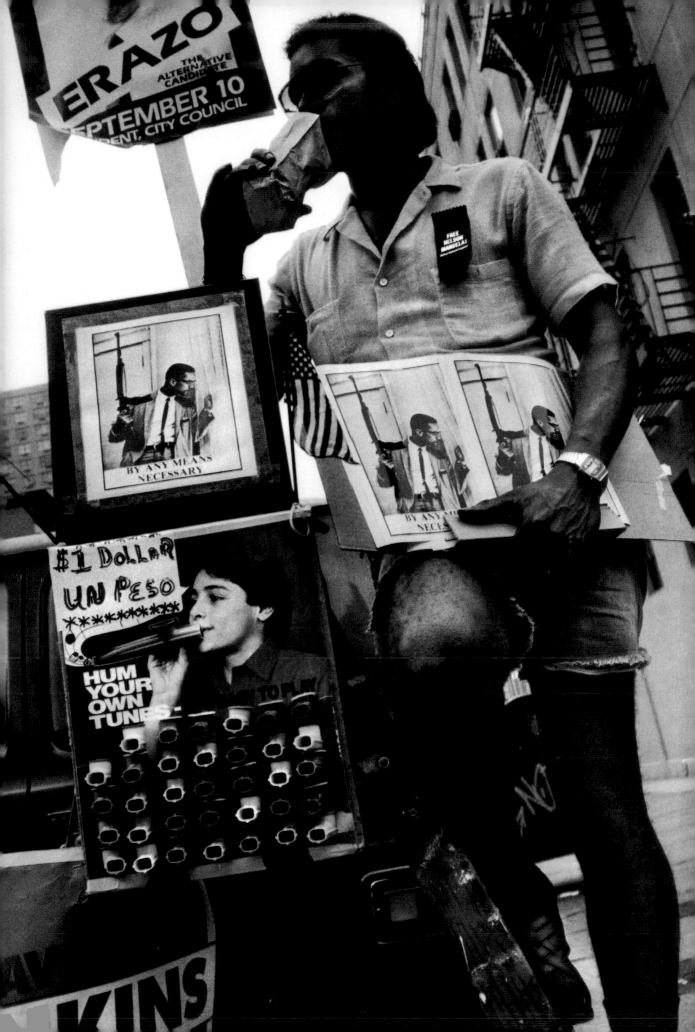

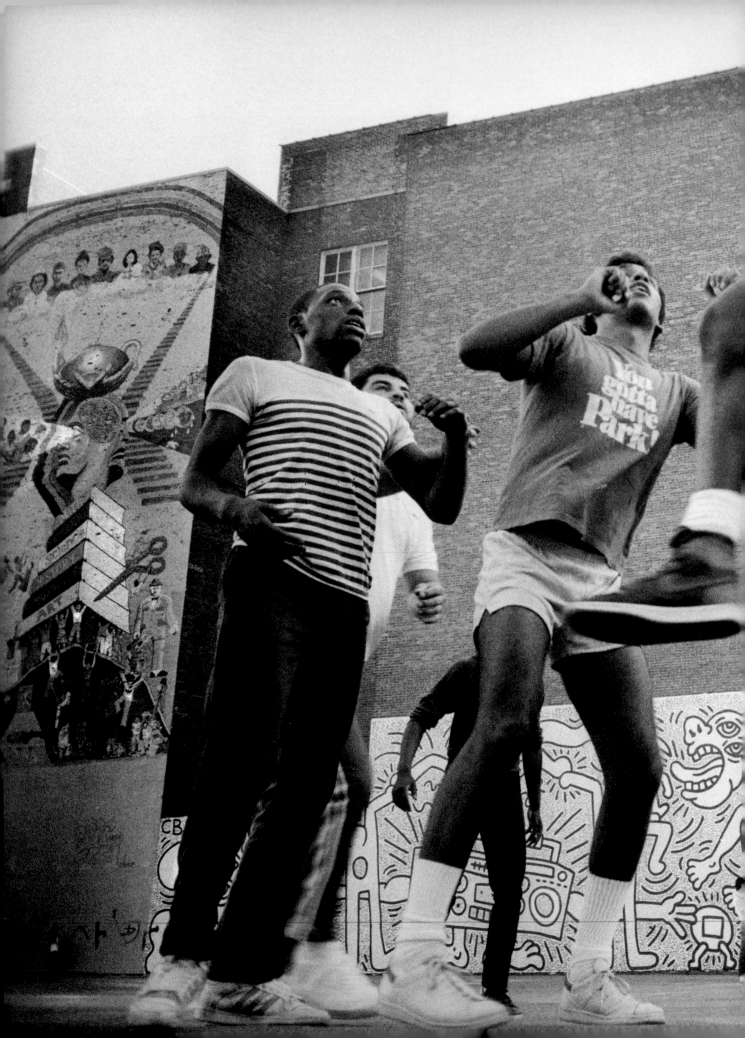

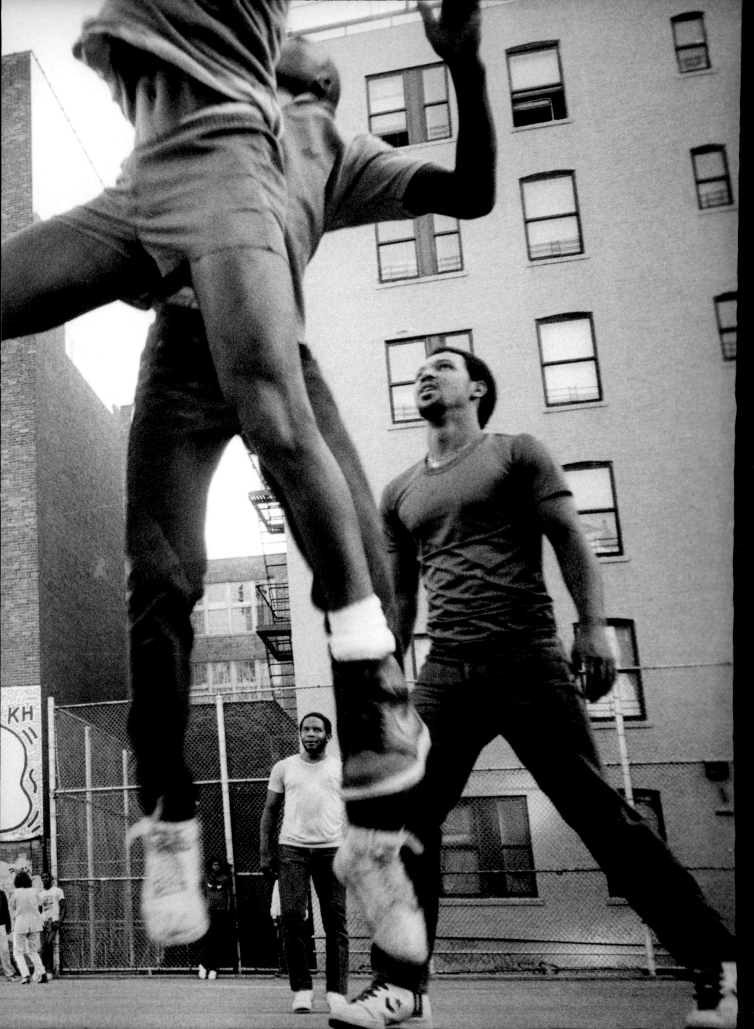

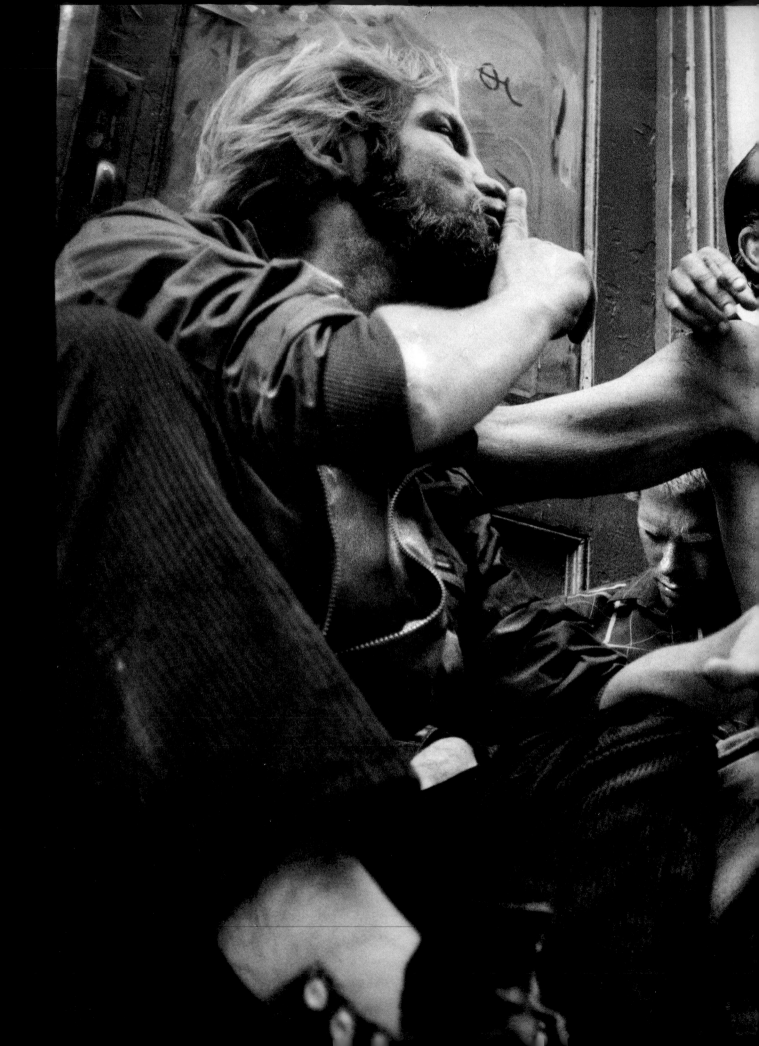

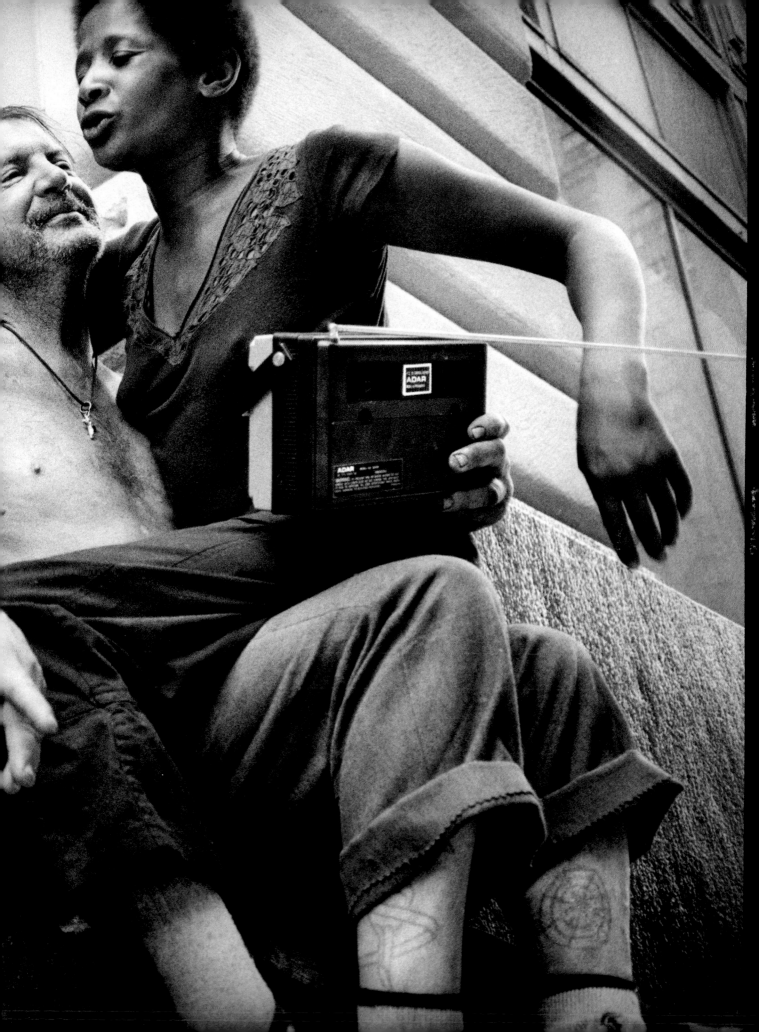

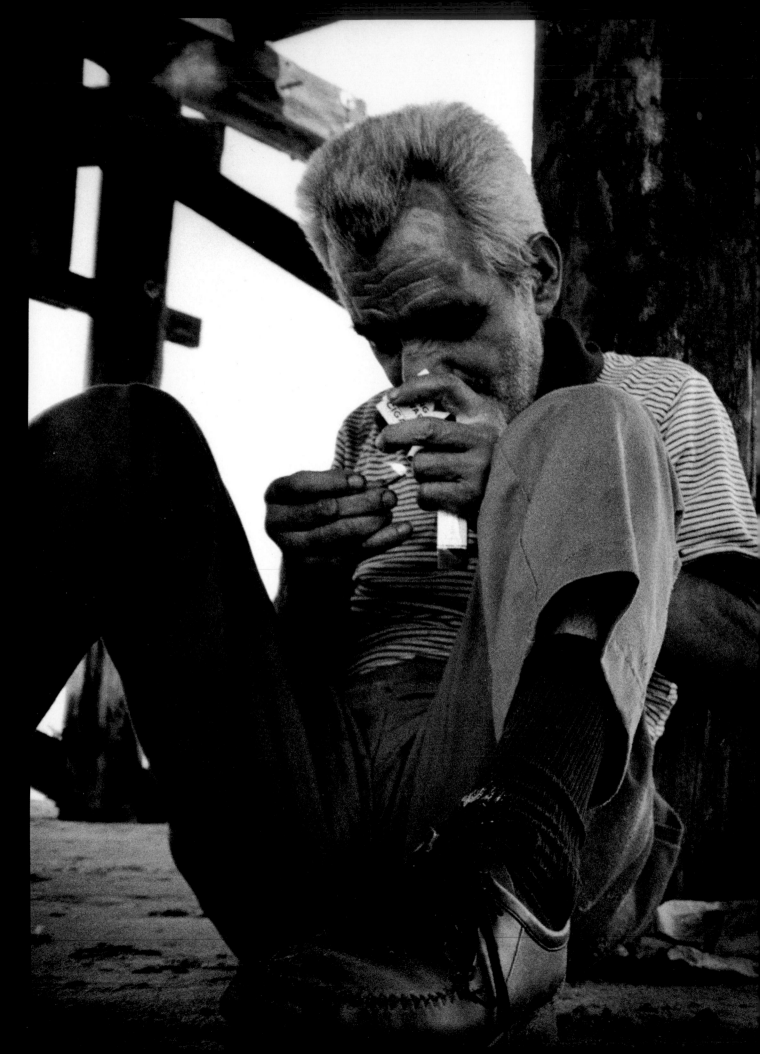

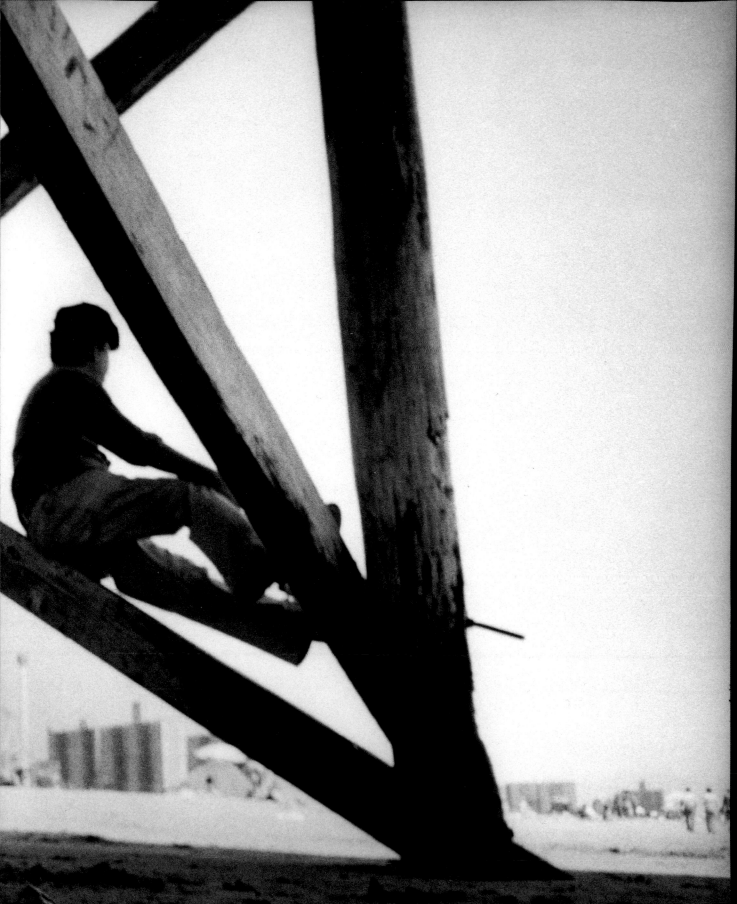

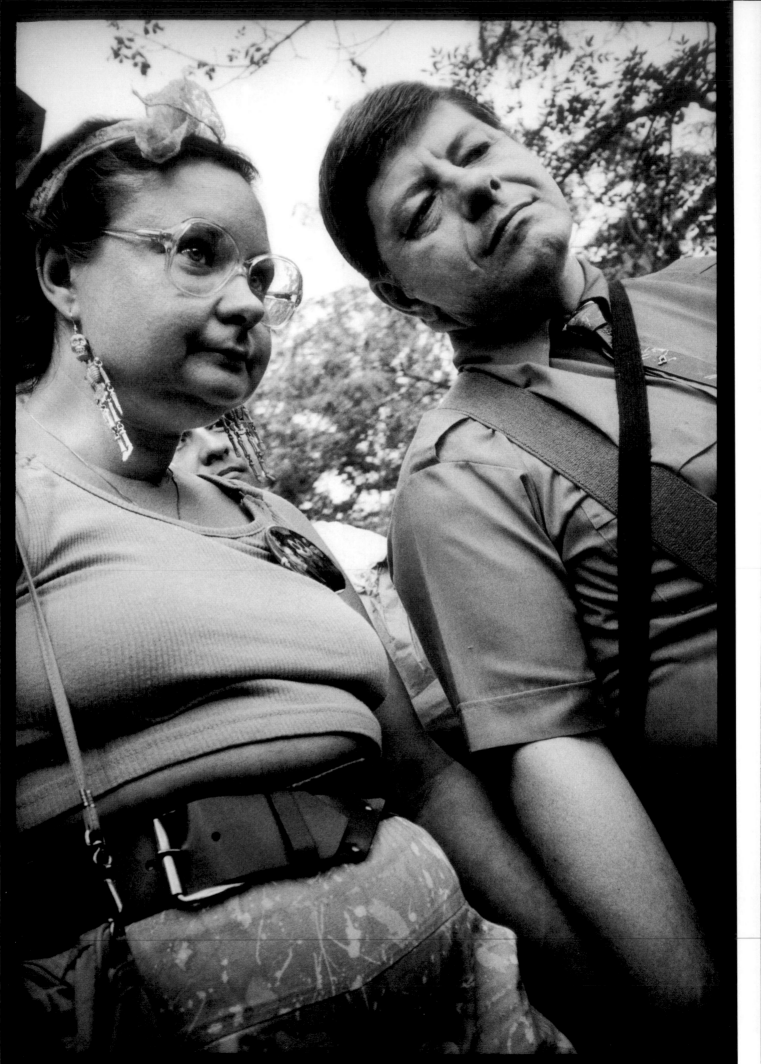

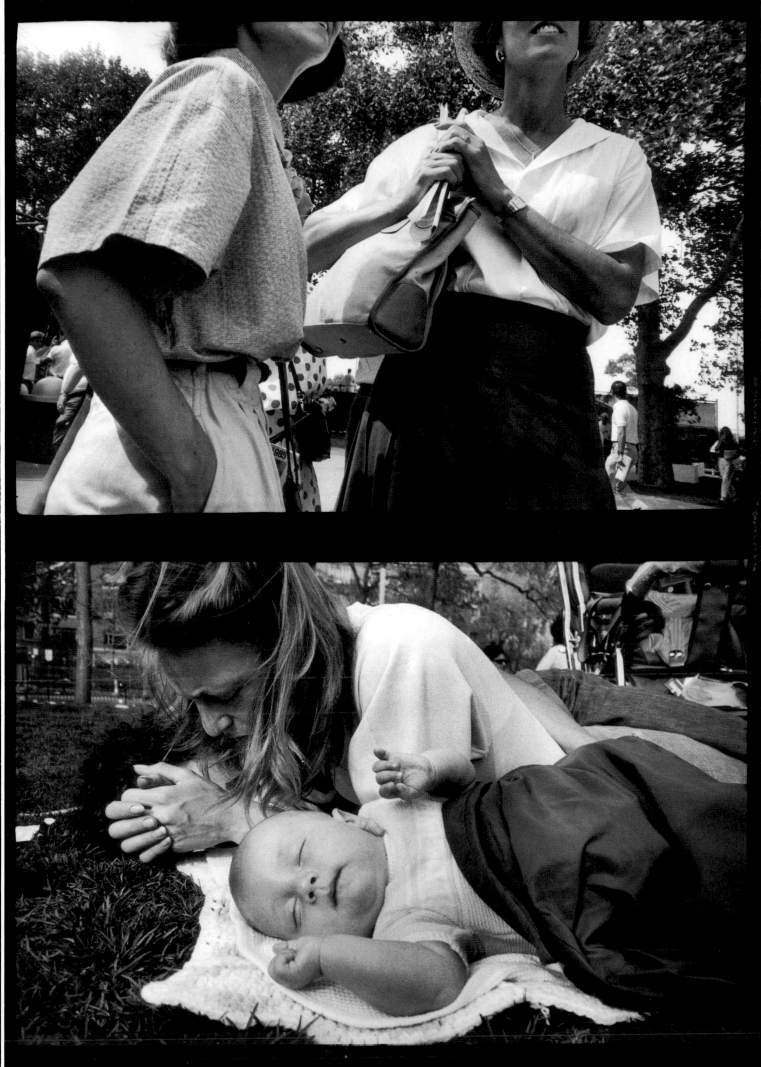

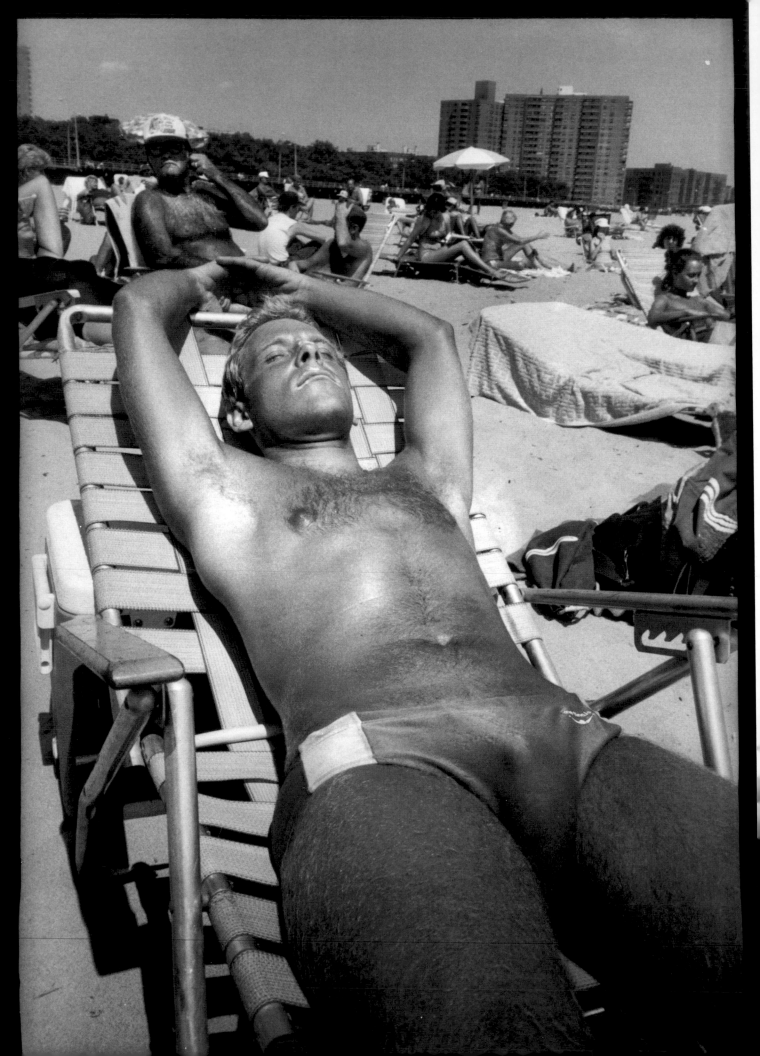

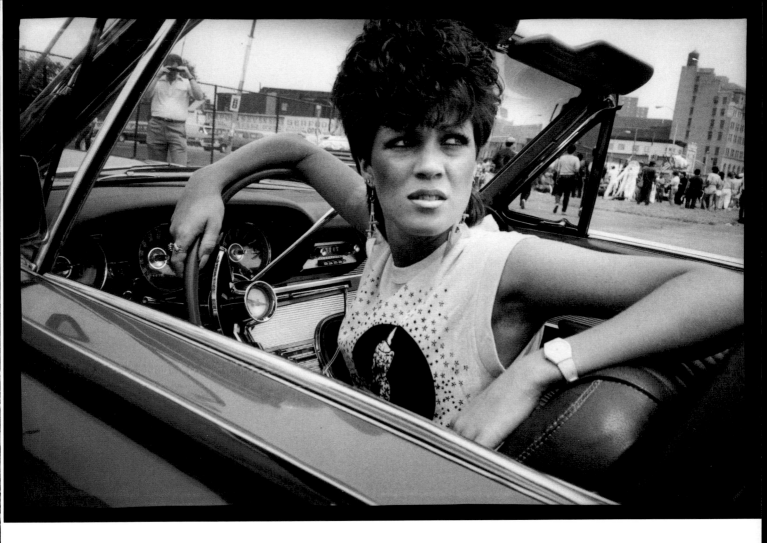

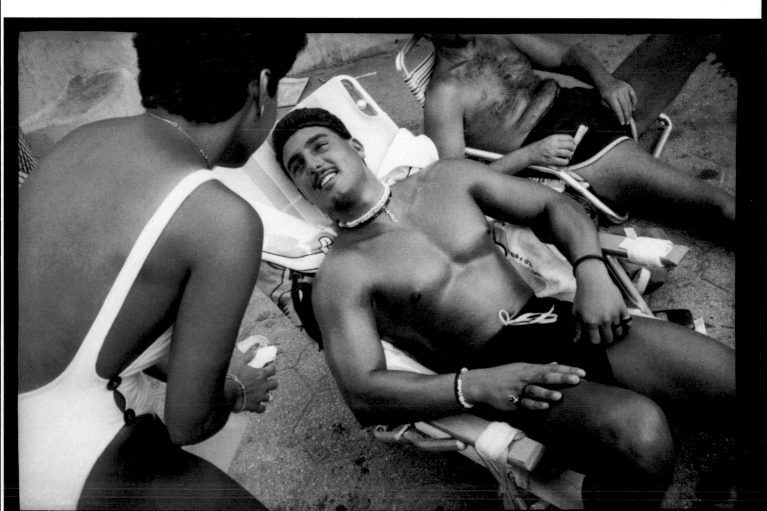

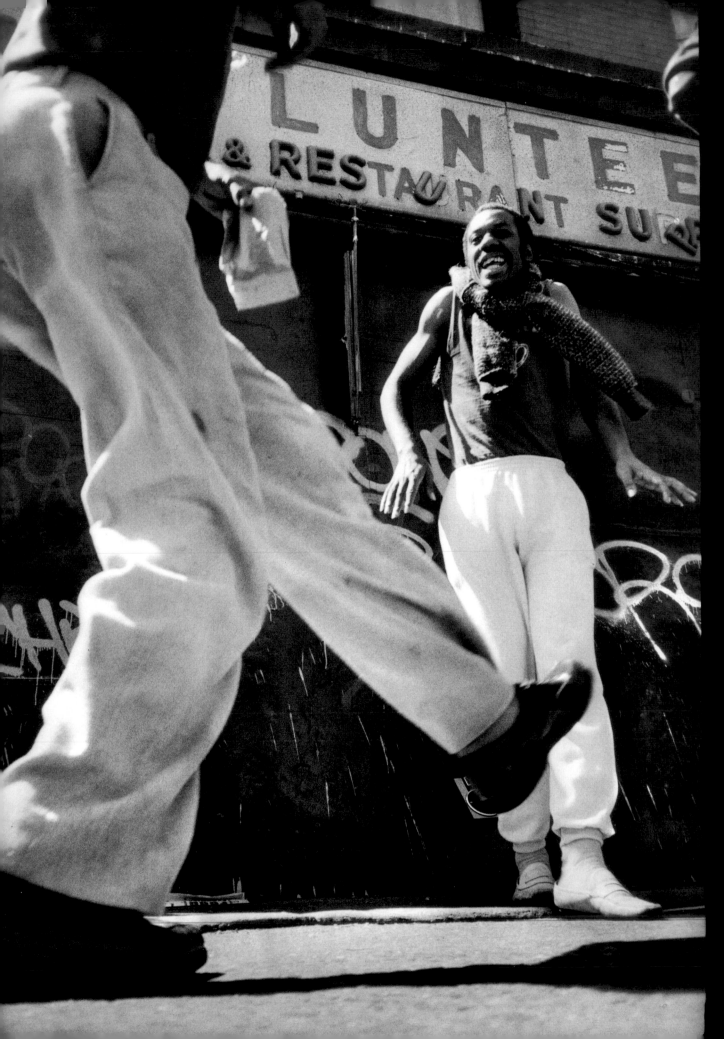

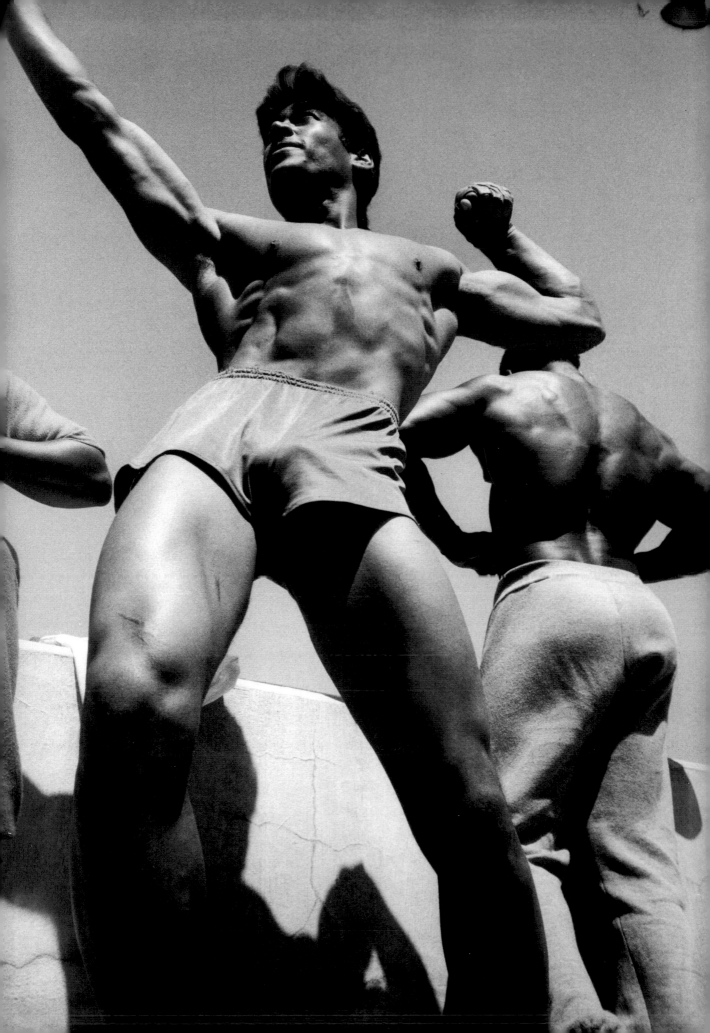

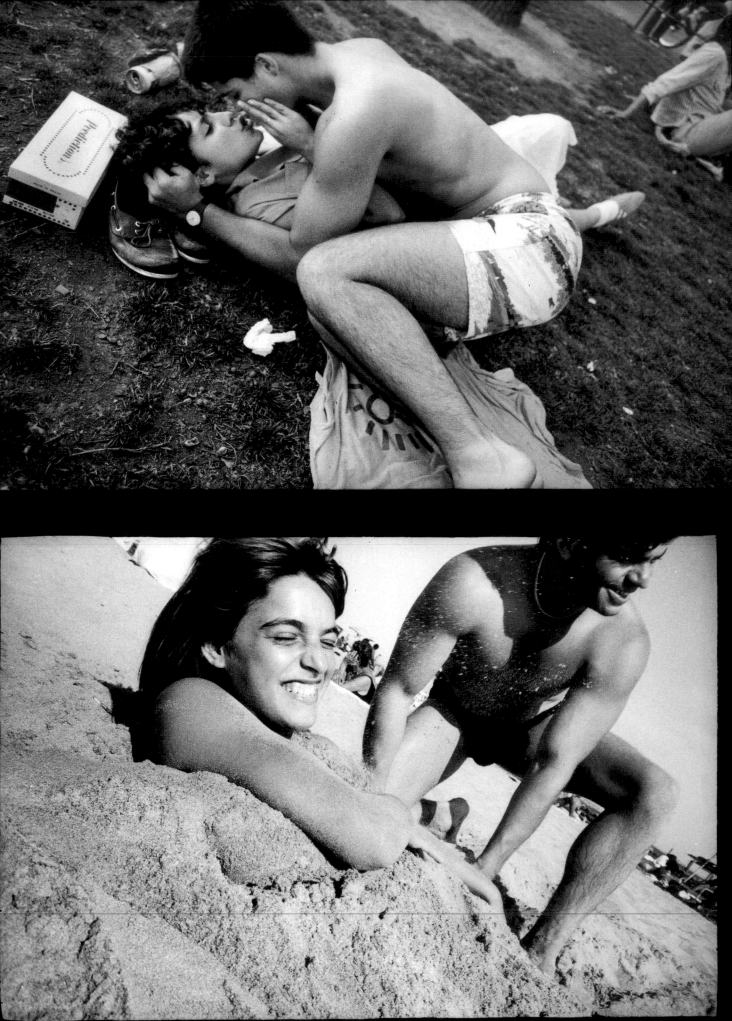

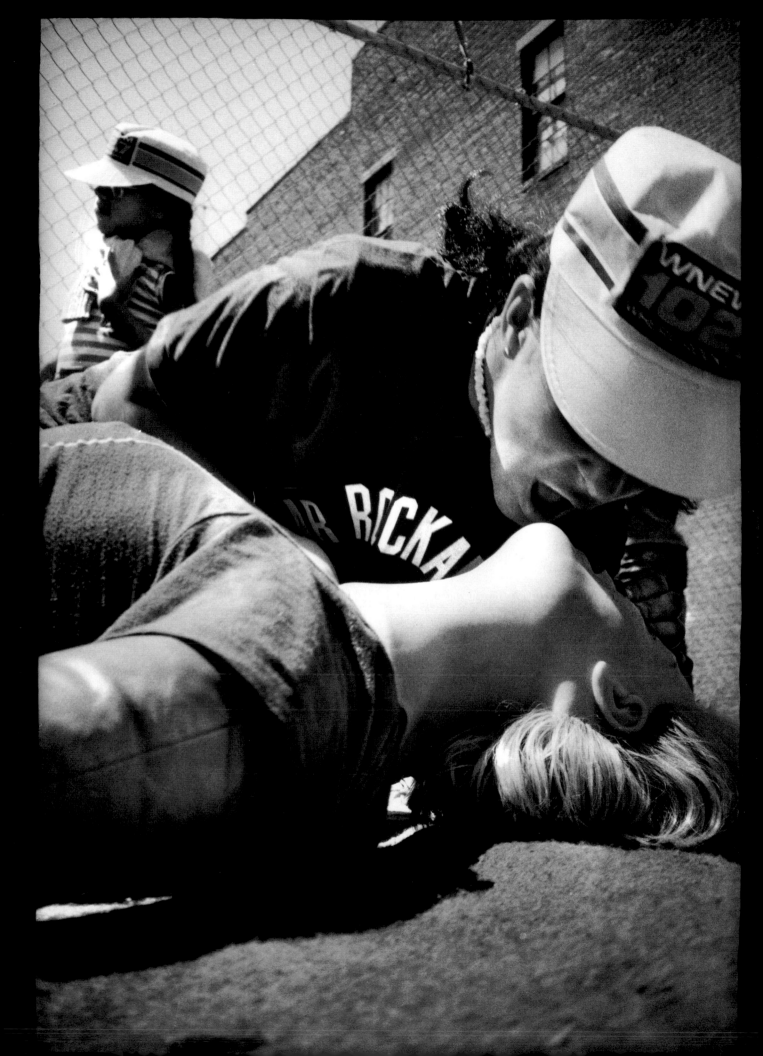

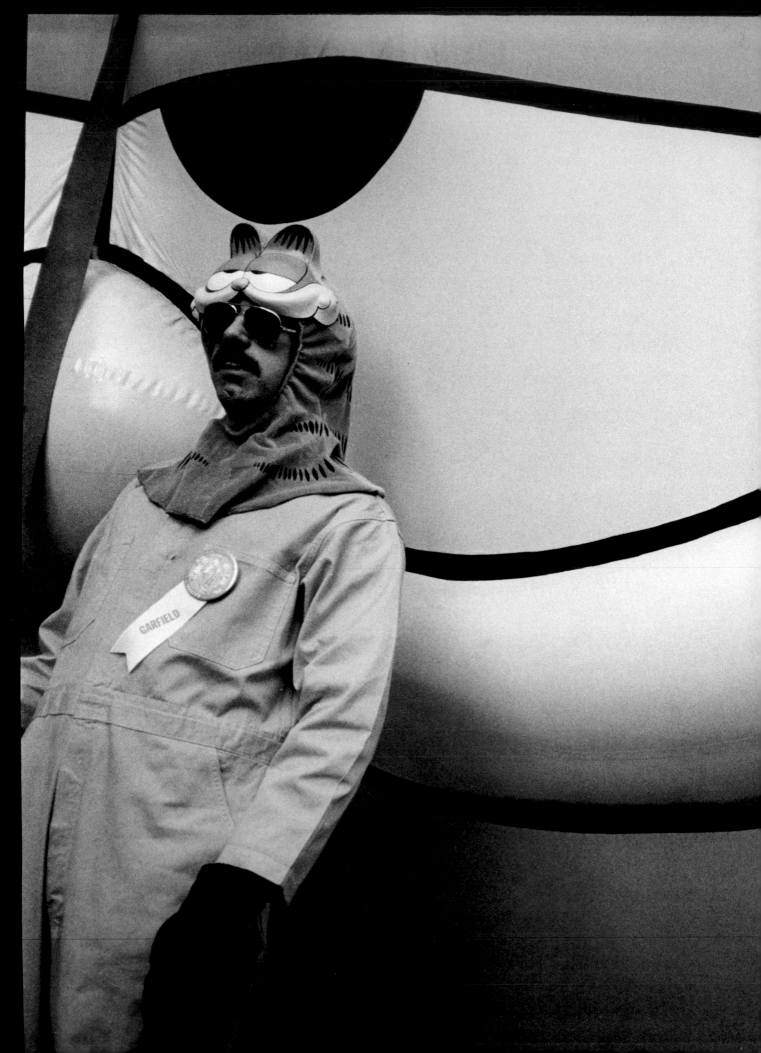

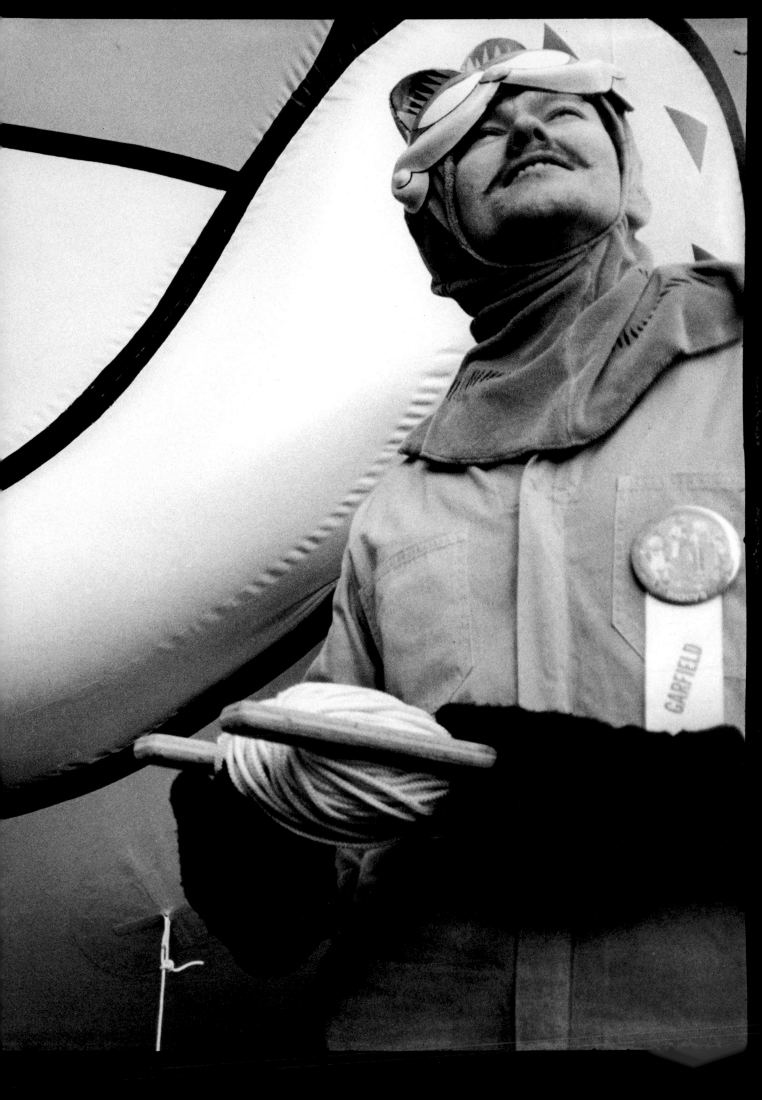

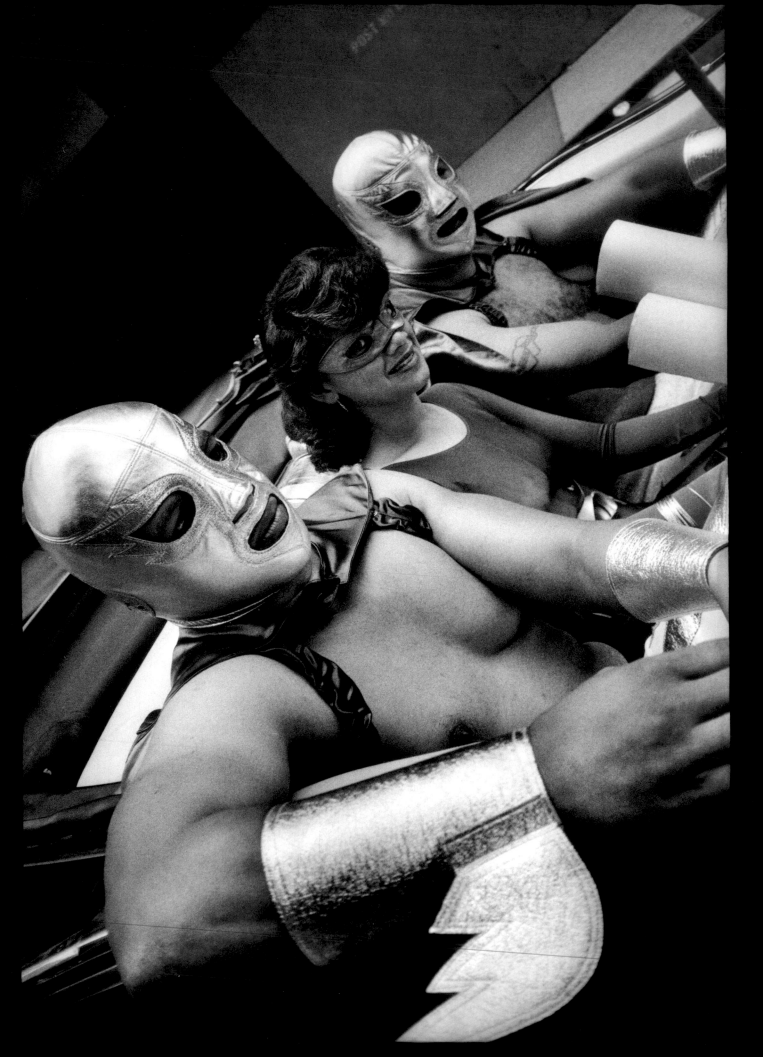

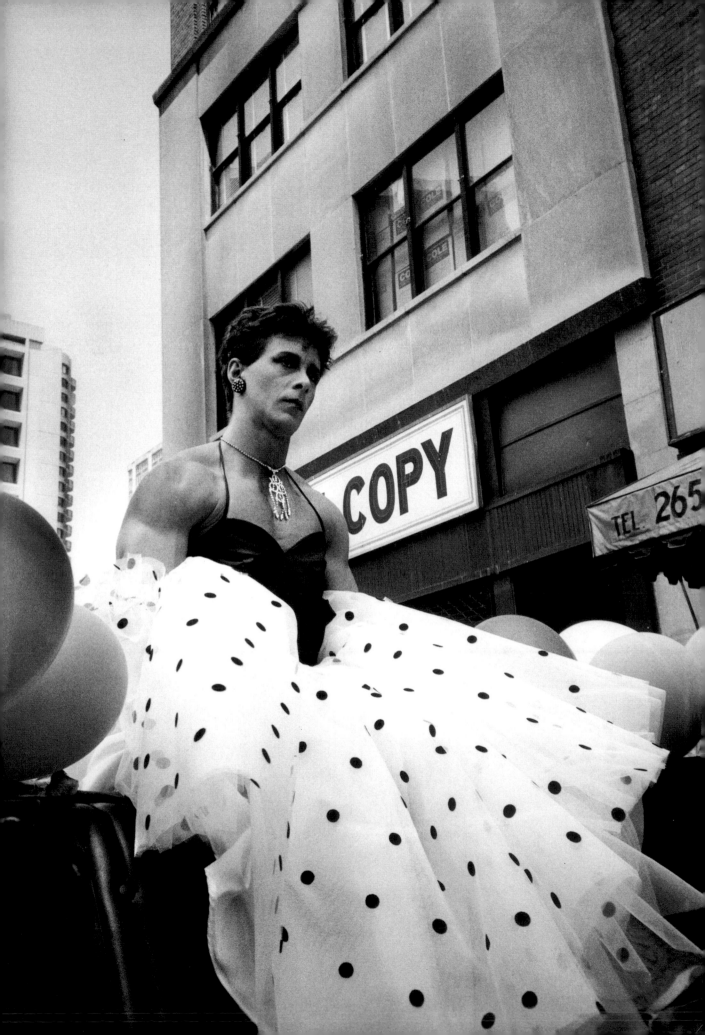

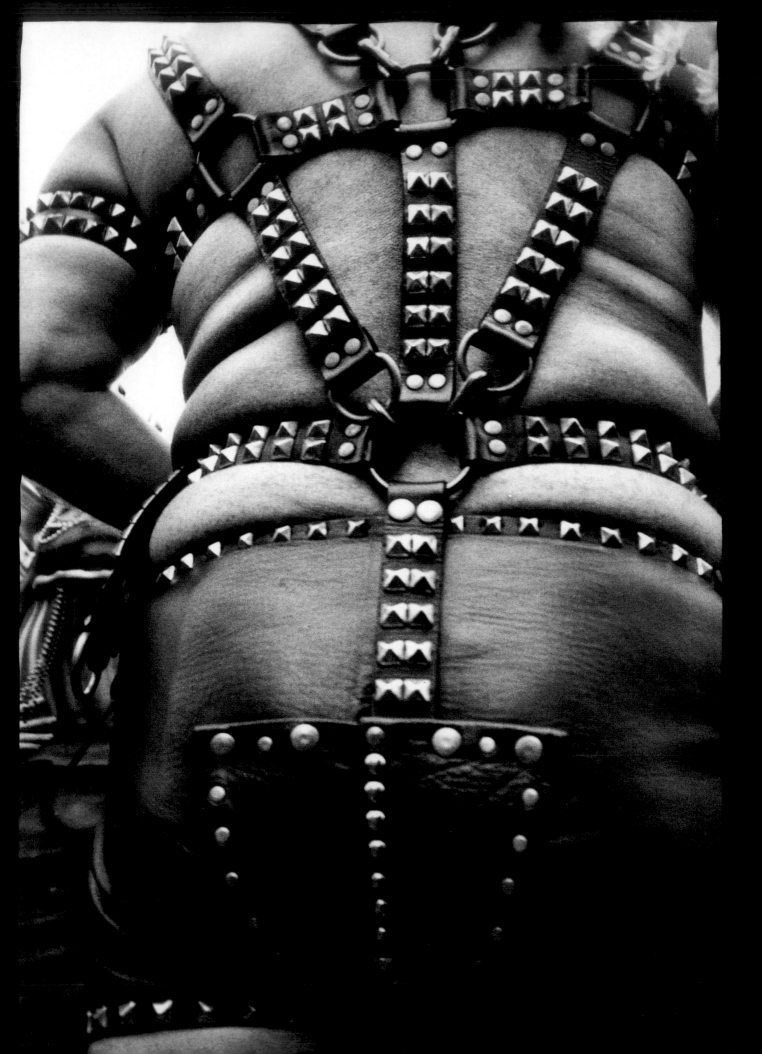

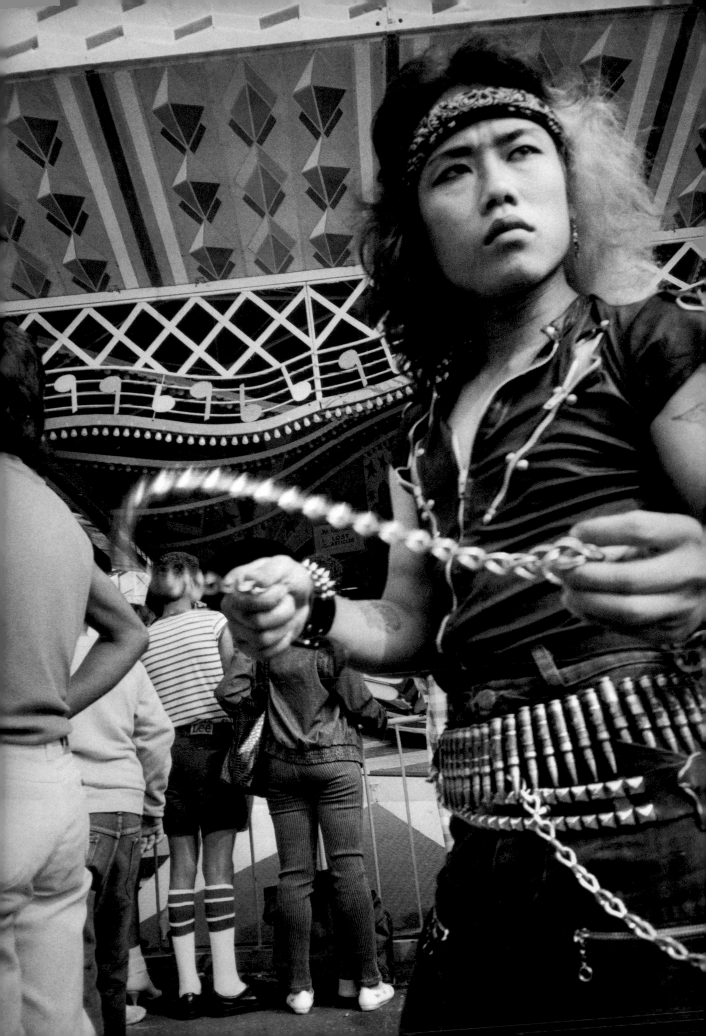

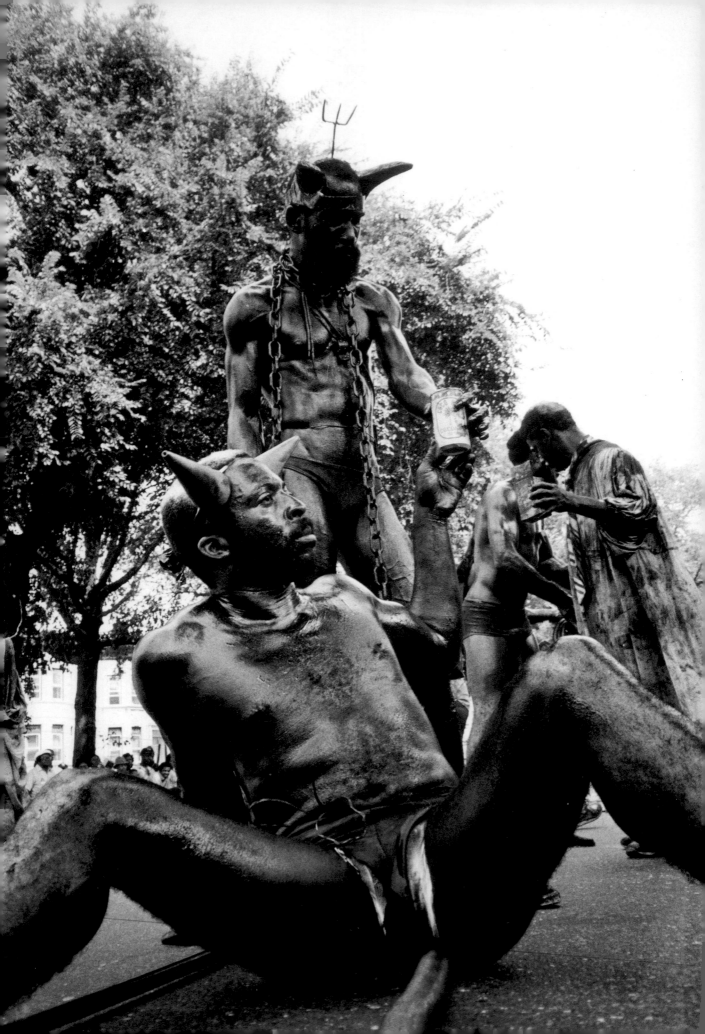

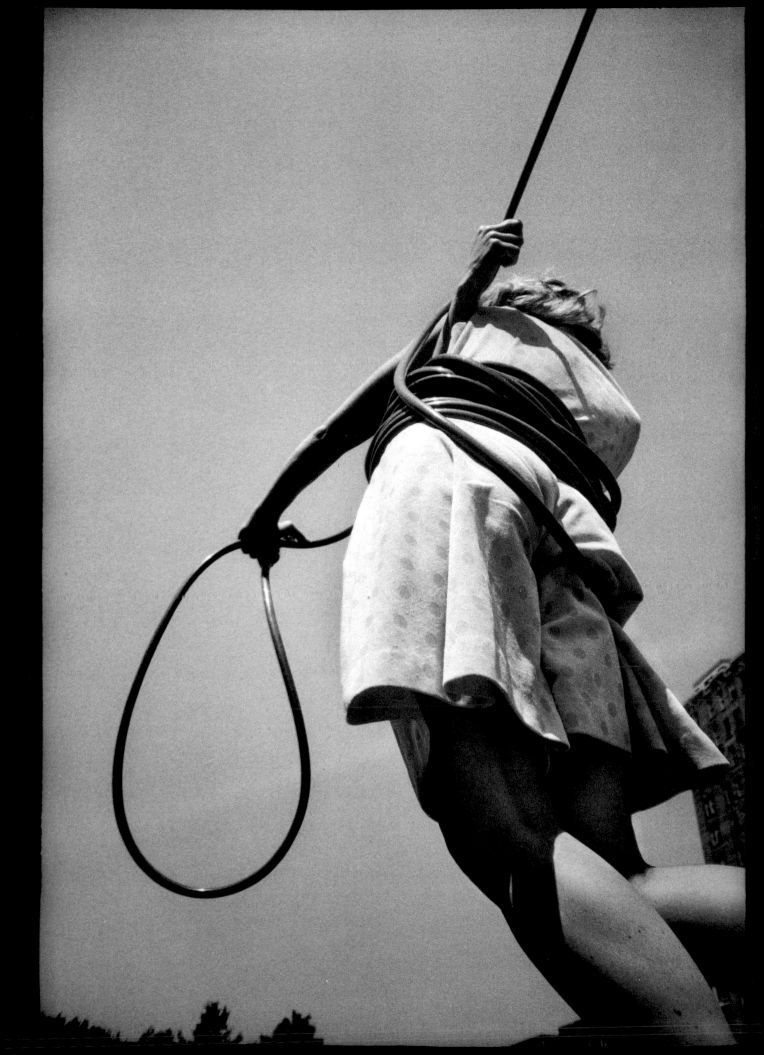

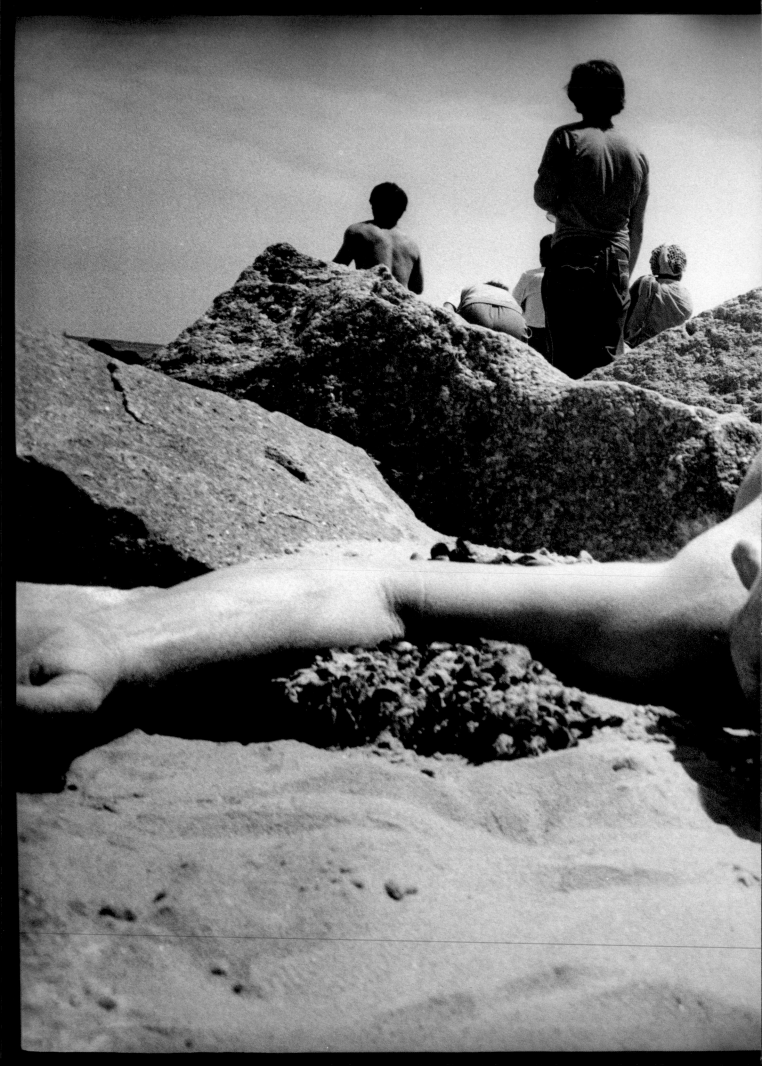

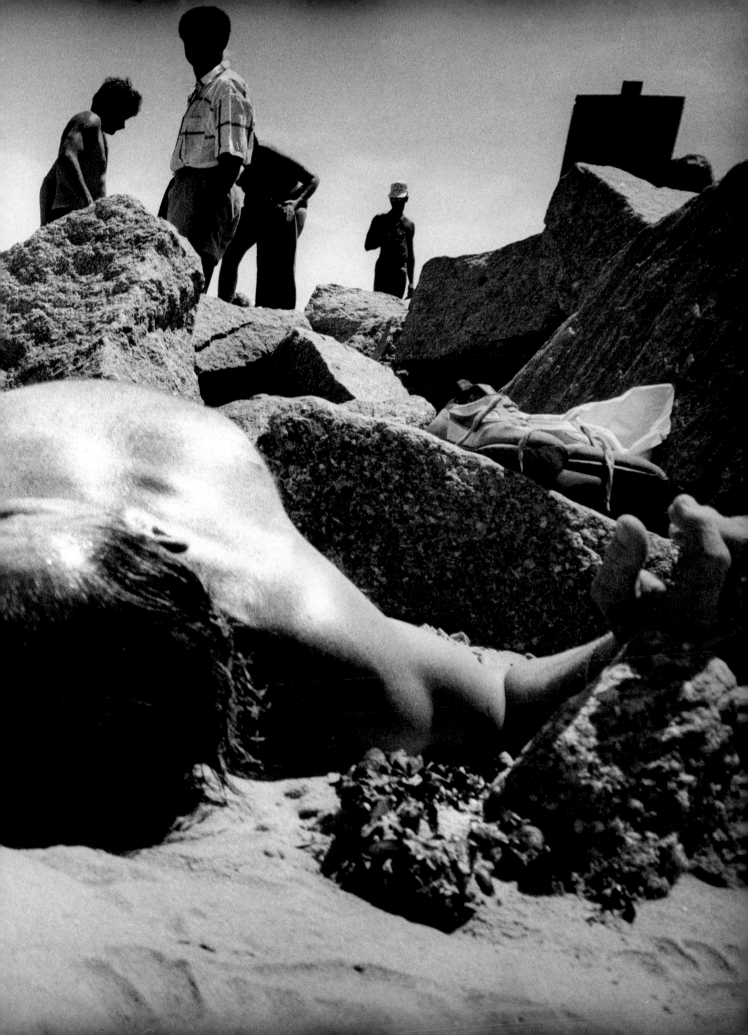

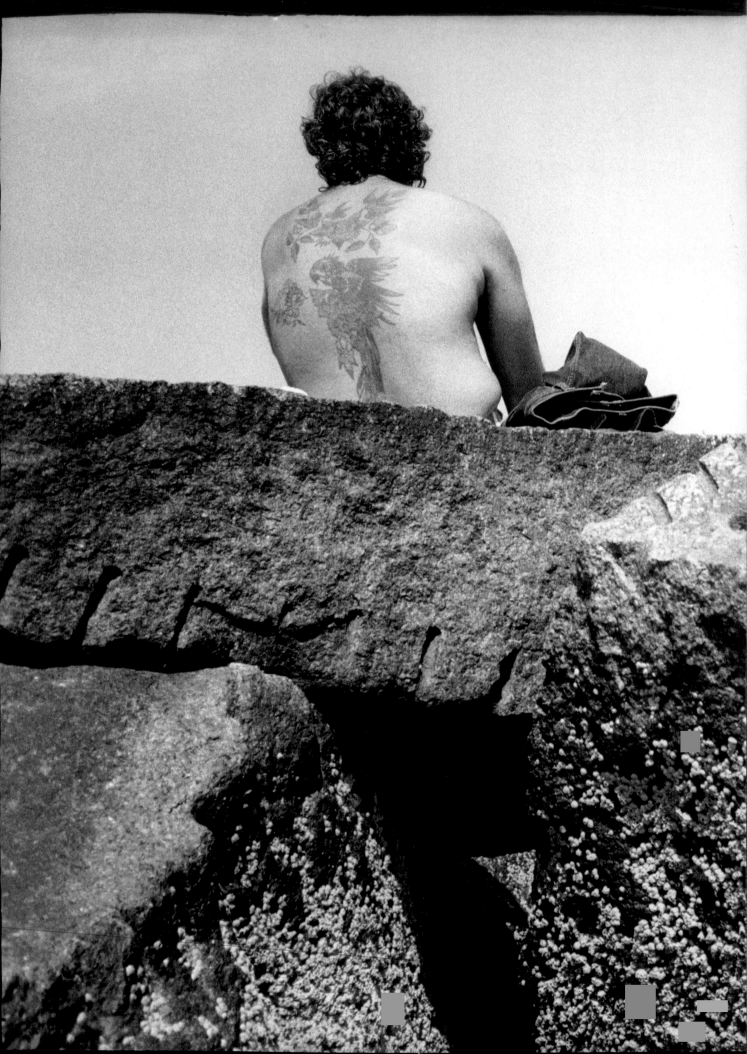

AFTERWORD

BY KEN HEYMAN

In 1984 I was in Toronto on assignment for *A Day in the Life of Canada*, along with 99 other photographers who had gathered for the opening reception. I was surprised to see that three photographers were carrying little plastic cameras, even though they had brought more sophisticated equipment with them. I asked the editor standing next to me why they were carrying these amateur cameras. He replied, "Buy one and you'll see!"

A month later I was back in New York City working on a story about drugs on the Lower East Side. Because of the heavy drug trafficking there, I was having trouble taking photographs; most people on the street thought I was an undercover cop. One day, out of frustration, I walked into a camera store and bought a "point and shoot" camera (like the ones I'd seen in Canada). The next day I shot a couple of rolls of Tri-X. Later, when I was looking over my contact sheets, frame number two jumped out at me. I couldn't explain the sense of disproportion of the woman in the booth, who looked enormous, compared to the woman walking just a few feet away. I'd never seen anything like it in my photographs.

That strange sense of scale seduced me—I had to see what else this "simple" camera might do. What I discovered were "hipshots." Holding the camera in my right hand, at about knee level most of the time, I just aimed and shot—the camera did the rest. I even went so far as to place the camera on the sidewalk, merely guessing at the appropriate angle to tilt it. What liberation! I didn't have to worry about focus, exposure, and the usual things photographers think about.

After a few months I learned what I could and could not do with the hipshot method. One of the biggest problems I had was to let go of the horizon line. Throughout my career, my editors had always demanded a level horizon. With hipshots, a level horizon line became unimportant. The viewfinder was replaced by my gut instinct. When I finally realized that these photographs were not for assignments, but for me, I felt even freer to explore.

My next discovery came when reading the contact sheets. In the beginning when I looked at the contact sheets, I felt discouraged because there were only one or two images worth printing. I was used to a much higher ratio. The pictures I had thought I had when I was photographing were not there. Then I went back to scan the proofs. Oddly, I saw that the best pictures were not the ones I'd been expecting, but the ones I'd overlooked as being insignificant.

After working in this method for a year I accumulated about five hundred 5×7

work prints. I lined both sides of my hallway from floor to ceiling with these images, and for three months lived with them, carefully combining and editing them. When people passed through the hallway I took notice of which photographs struck them. I spent many hours pacing up and down this narrow passageway discarding pictures, adding others. The hall became a laboratory for this book.

I want people to react to my photographs. A lot of the art I see in the galleries around where I live in Soho is unemotional. Why bother? I'm more from the "Family

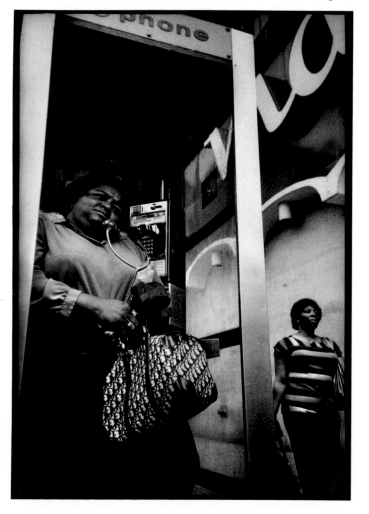

of Man" school because I think photographs should have emotional impact: that's how they can make a difference. I remember the long bus ride I took to grade school through different neighborhoods in New York City. I'd stare out the window at places I never set foot in. It was like a movie I wanted to remember and share with my friends. Photography is a way to do that, even make some changes.

The *Hipshot* images have "contents"—specific times, places, and subjects. But their sequence in the book makes them more like Rorschach tests: there is no "solution" to be figured out from clues. I point my camera, not to moralize or indulge, but because I notice. What viewers make of the work is up to them. It's more interesting that way.

Library of Congress Catalog Number: 87-071951
ISBN: 0-89381-293-5
The staff at Aperture for *Hipshot* is Michael E.
Hoffman, Executive Director; Steve Dietz, Editor;
Lisa Rosset, Managing Editor; Stevan Baron,
Production Director; Jason Greenberg, Tessa
Lowinsky, Editorial Work-Scholars. Sequence by
Ken Heyman. Book design by Wendy Byrne.

Aperture Foundation, Inc., publishes a periodical,
books, and portfolios of fine photography to com-
municate with serious photographers and creative
people everywhere. A complete catalog is avail-
able upon request. Address: 20 East 23 Street,
New York, New York 10010.

All of the photographs in this book were taken
in the five boroughs of New York between
August 1984 and December 1985.